VICK

Short Stories

Just a Little Southern

ISBN 978-1-64140-012-1 (Paperback)
ISBN 978-1-64140-013-8 (Digital)

Christian Faith Publishing, Inc.
296 Chestnut Street
Meadville, PA 16335
www.christianfaithpublishing.com

Printed in the United States of America

Everyone has a journey to take, and it is up to us to make our own journey great. I give God all the glory and thank Him daily for my family. I dedicate these stories to those who walk with me no matter where my journey leads and who judge me not when I may take a wrong turn along the way.

Contents

Confessions, Baptist Style

Never have I been embarrassed to say I grew up in a trailer park. Let's just say you can meet some interesting folks there and leave it at that. And besides, it made me who I am today—an interesting person, to say the least.

Take the night me and my little sister met God. Well, at least we thought it was Him. My sister, whom we call Toot, and I were sound asleep in the front bedroom of our stylish three-bedroom, two-bath trailer. Or should I say mobile home 'cause we were kind of uppity at times. Now because our sleeping quarters had a big bay window all the way across the front and a double window on one side, we were privileged with headlights dancing across our bedroom walls at all hours of the night. To this day, I would like to personally say thank you to the person who thought sheer curtains were awesome in a trailer park, but you get used to it. Anyway, back to my story at hand. One night, Toot and I were awakened by the biggest light ever piercing down into our room. It was just hovering there. After a few minutes of lying there perfectly still, Toot asked, "Is that God?"

Not being sure myself and wishing I had paid a little more attention to those lessons that the big bus took us to on Sundays, I answered, "I think so." The light was just there as if it was waiting on us to do something.

"Go get Momma. I scared," pleaded my little sister.

Well, I wasn't moving. No way. "What does He want?" My little sister wanted to know. Toot would not be quiet, and I was thinking if this was some sort of biblical ritual that I hadn't learned about yet. I could pitch her out the window into the light easily. I just needed a little direction from up above.

Then Toot began confessing her sins. "I took brother's candy. I stuck my tongue out when Mommy wasn't looking. I don't like green beans."

Well, that got me to thinking I may be in more trouble than Toot because I had also found brother's candy stash, and I didn't like chicken livers. Unbeknownst to my mother, for years, my brother and I had been secretly pitching those livers into the garbage can when she wasn't looking. Not to mention, I was five years older than Toot and my list was way longer. By this time, we were huddled close together, just waiting and confessing. I would like to think God was up there, laughing out loud. I am sure it was not as long as it seemed before the light lifted up and moved away, but at the time, it seemed like hours.

I will say one thing—a good confession does the body good. God never came back to us again like that, and come to find out later, it was just a helicopter picking up a stabbing victim two trailers down. To this day, I get tickled because my first and only confession was to a helicopter. Of course, Toot turned out Catholic with a whole pack of children. I, on the other hand, stayed Baptist and giggle out loud each time I see one of those things flying in the air. Life is good, and I learned to take those trailer park memories with me each step of the way.

Living among High Society

Tonight, as my brother Bill and I were sitting across the table at the catfish house, we shared a good laugh reminiscing about the "yonder" years. It was mostly about how my mom and dad had three kids, Bill and I being sixteen months apart and members of the lower class, while our baby sister, born five years later, was somehow connected to royalty. Never really understood how that happened. I think it had something to do with her red hair. Remember, this was back before the government got involved with raising up your kids. You know, back when it was okay to leave your kids in the car while shopping in the air-conditioned grocery store for two hours. So Bill and I were enjoying the Mississippi summers stuck waiting in the Volkswagen while Princess Terri got to ride around in the shopping buggy. Every once in a while, we could see her passing by the storefront windows eating cereal out of the box. Although I could understand why my mother would not let "Wild Bill" roam the isles, but why wouldn't she let me? To this day, I have yet to knock over a six-foot-tall display of spray starch. But you let your brother cause that to happen just once, and suddenly, you are banned to the metal box on wheels outside.

Long before the trailer park years, we lived on the coast. Right smack dab in the midst of a nice subdivision on the beachfront were two little rental houses just alike. Somehow, my parents managed to get us one of them. Now granted, we may have been able to see the beach from our front yard, but we were not allowed to put one foot on that Highway 90 to get to it. It was probably best anyway. Bill and I seemed to always be plagued with bad luck. We would have probably just got run over trying. And by this time in my life, I had

already been run over once and survived, so no need to do that again. Yep, that's always been my motto—try everything once.

Anyway, back to my story. There were lots of young boys on our street, and Bill was friends with most of them, even the really, really rich kids that lived one street over. Yes, sir, we had hit the jackpot in this place for our little rental house backed up to a fancy private golf course. Sometimes, the golf balls would land on our side of the fence, and it did not take Bill and me long to realize we could gather them things up and sell them back to the rich folks. Insert big smile and nodding head. Yes, sir, we were getting rich. Not really, but at the number nine hole, there was a snack store that we could sneak into and buy Cokes and candy bars with all those nickels and dimes we got from selling those golf balls.

There is something you should know about fancy golf courses: they are real picky about their grass, and those fancy folks are not too keen on letting you play around on it. And believe it or not, they are especially sensitive about golf carts dragging a piece of plywood, loaded up with the neighborhood kids. Just ask my brother, Bill.

Another thing Bill would like to point out is if you notice a new house going up across the street, it is not wise to use some of the lumber to build a fort, especially not a two-story one. It was probably a big clue gone unnoticed by my brother when the older boys said, "Y'all be the lookout." Yeah, in hindsight, these words should always be red flags, no matter if one of the boys' fathers is the district attorney or not. Just ask my brother, Bill. When a few of the dads made their way down the beaten pathway to the luxury fort, it was not good. Those boys had fun, but Bill said, "Dang, these rich kids can get you into some serious trouble if you are not careful."

I will say that Bill did not need the rich kids helping him out because he could find trouble all by himself. Take for instance the day he and Dad were riding to town in our hand-me-down land yacht. He found a piece of gum on the dashboard, and I can just hear him now, "Free gum!" Insert lesson on what happens when gum has been riding on the dashboard in the sun too long. I'll have you know, that stick of gum exploded into strings of sticky mess once he started chewing. He liked to have choked to death before he got

all that stickiness balled up enough to spit it out into his hand. This turned out to be mistake number two. He may have got it out of his mouth and into his hand, but that did not mean he could get it out the window without my dad noticing. That sticky mess traveled all the way down the side of my dad's freshly waxed car, and there was nothing he could do but hold his hand out the window and watch it fly through the air, all the while still stuck to the tips of his fingers. By the time my dad noticed, that boy had a string of gum all the way back to the vehicle traveling behind us. Not to mention, the right side of our car looked like Spider-Man had declared war on us. I kid you not.

As most boys do, my brother signed up for baseball, and since Bill was having trouble making contact between the bat and ball at the games, my dad decided to do a little practicing. First pitch my dad threw resulted in a hit, right through a windowpane of the neighbor's fancy little cottage. Insert Dad making a trip to town and spending the morning making repairs. To my brother's surprise, Dad decided to continue the batting practice once the window was fixed. Now you will find this hard to believe, but that second pitch resulted in a hit right through the same windowpane of the neighbor's fancy little cottage. I kid you not. This time, practice was over for good. We just could not afford Bill playing baseball anymore.

Horsefly Heaven and Jellyfish Beaches

Life in the trailer park was not all pea patches and butter bean fields. There were some fun times too.

Like when we got to jump into Uncle James and Aunt Janie's pool after a long day of working in the garden. I remember one time when my brother Bill grabbed his swimsuit off the nail and found a wasp had set up housekeeping in them while we were out in the fields. The only thing worse than finding a wasp in your shorts was finding the dressing room full of girls. Needless to say, it did not take long before he was running butt naked and making a beeline for the pool. Turned out that my brother was allergic to wasps. For weeks, every time Bill got near any of our cousins, he had to listen to them sing the Ray Stevens's song about streaking.

I remember one time our country cousins offered us a week of vacation in the woods. Shoot yeah! How could we pass up a week of living like the rich and famous? These cousins had a camper in the back of their woods overlooking a scenic view of the river, and we could enjoy all of Mother Nature's beauty for free. Bill and I strutted around that trailer park acting like we were something.

Insert nodding heads.

"We are going on vacation" were words seldom spoken from within the trailer park. Momma loaded up that Volkswagen, and we were on our way. I believe one of the uncles unlocked the gate and escorted us all the way to the back of the land. We passed through fields and fields of nothing but green grass. This was back before the days of video games and television sets with two hundred channels on them. Children played outside. You either went outside on your own free will, or you went being escorted by Momma's little switch.

I remember thinking as we followed my uncle through those green pastures, *Boy, I can't wait to play out here!* My brother could not wait either. We could run and jump and hoot and holler all we wanted to. Turned out there was one small problem with our field of dreams— horseflies. I do not know what kind of nuclear experiment they had going on in this county, but those things could actually eat a horse. Once we got the car unloaded, we spent the next few hours inside our luxury resort killing horseflies with our two-dollar shoes.

I would like to state for the record, while Bill and I were busy dealing with some sort of Old Testament plague, my sister was hiding in the tiny bathroom screaming, "I wanna go home!" Yep, for one solid week, we had traded our big house on wheels for a little one, deep in the woods of Marion County, surrounded by a million hungry horseflies. I will say my brother Bill had it worse. Apparently, he was also allergic to those things as was now evident by the golf-ball-sized welts all over his body.

I cannot mention vacations without also talking about the time our city cousins asked us to go to the beach with them. Finally, it was a real vacation. We jumped out of that VW bug, slinging towels and beach toys everywhere. Even as the hot sands were burning the top layers of skin off the bottoms of our feet, we could not stop grinning. In record time, we had those ten-cent floats blown up and in the water. I bet you did not know, but you have to walk five miles out into the Gulf of Mexico to get the water up to your chest. Soon, we were enjoying the good life.

About thirty minutes into our so-called good life and without any warning whatsoever, the boys left our adventure and headed back to the shore.

"Wonder what those crazy boys are doing?" I said, as they swam passed us at record speed.

My little sister raised her head off her float and said, "If they eat my moon pie, I'm telling Mom." And with that final declaration, we were introduced to the world of jellyfish. What layer of fresh Hades had we stumbled upon now? Clearly, we had accidentally crossed over into Mexico because those things did not understand my sister's

threat. "They are eating me! Stop it! I'm telling Mom," screamed my little sister.

With each row of our arms, those creatures were taking little bites. Since my sister had latched onto the back of my float, I had to paddle for the both of us.

"Help me paddle, Terri! Help me paddle!" I begged.

It appeared we were not getting anywhere fast, and by the time I dragged my screaming sister back into the United States of America, I'd had enough of being rich and famous. I will say, my brother Bill had it worse, though. Apparently, he was also allergic to jellyfish, as was apparent by the golf-ball-sized welts all over his body.

On the long way back home, my brother and I told our mother, "Just let us play at home with the other poor kids, okay?"

Honestly, we were never going to fit in with the cool kids at school if we kept looking like we were spending our weekends at some government testing facility. And let me just state for the record, as my sister was sitting up in the front seat, eating the last of the moon pies, she once again managed to escape without looking like she took part in the government experiments.

The Volkswagen

Last night at my niece's birthday party, I was asked to write the Volkswagen story—a legend in itself. In 1966, my parents bought a new shiny red Volkswagen Beetle Bug from Steadman Motors in Hattiesburg, Mississippi, for $1,835. They paid $153 a month until that jewel was paid off. I asked my mother just how she remembered all those details, and she declared, "I really don't know because I have trouble remembering what I just left the kitchen to get."

My siblings and I learned to drive a standard in it—a feat that would give any parent instant gray hairs. And while I have it on my mind, whoever thought it would be fun to put a stop sign at the top of a steep hill was an idiot. I seriously thought my dad was going to have a stroke before I finally got that car stopped at that sign. Looking back now, I can see how rolling down that hill backward three times was a little nerve-racking and the reason my dad lit up that cigarette. Eventually, I got a handle on that clutch-brake-gas pedal combination.

As you know from a previous story, Mother took us to the pea patch and butter bean fields in that thing too. It really was a wonder the tires did not pop out from under that car. By the time we emptied our five-gallon buckets of fresh produce, the only places left to sit were on the hood or on top of the vegetables—the front seat being reserved for Princess Terri, you know. It was a good thing that car had a rounded top. Insert my brother and me sitting high on a pile of butter beans with our heads crooked and pressed up next to the rounded dome. Good times, I tell you all, good times.

There were many trips to the creek in "Old Red" where we played in the ice-cold waters, swinging off the ropes and having picnics on the banks. And there were also trips to Sandy Hook,

Mississippi, where we visited with our country cousins. One time, my little sister's cat, Tinkerbelle, got to ride with us on one of those long hot summer days. Who knew cats could get car sick? Folks, there is nothing like riding in a vehicle, in ninety-degree weather, with a cat having stomach issues. What that cat needed was a giant litter box, but what that cat got was a floorboard, the car seat, most of our clothes, and everywhere else she dang well pleased.

Oh sure, before this trip through Hades, Bill and I weren't allowed to even touch Terri's cat. I can still hear her yelling now, "Stop touching my cat!" But just as soon as that thing started smelling up the red box on wheels, Terri wanted no part of it.

"Put that stinking thing in the back seat, right now," Mother said, as my sister declared she now wanted a hamster instead. When Bill and I realized what was fixing to go down in that Volkswagen, we suddenly decided we didn't want to play with the cat anymore, but it was too late. That stinking mess now belonged to us.

"I don't wanna cat, Momma! That's Terri's cat," we both pleaded—but to no avail. Insert Bill and me now sharing less than half of a Volkswagen back seat, gladly giving the rest of it to the cat.

"Roll the windows down, Momma, roll the windows down!" Billy and I continued to yell.

There is something you should know about Mother. She drives forty miles per hour regardless if it is highway or driveway. We wheeled "Old Red" into Marion County a few hours later. Yeah, ain't nothing like showing up at your relatives smelling like you have been playing all day in the litter box. Not my finest hour, I tell you, not my finest hour at all. Come to think of it, I am not sure Tinkerbelle was in the car with us for the trip back to Hattiesburg, but I do know Terri named her new hamster Orbit.

But let me get to the legendary of all "Old Red" stories. As some of you know by now, Princess Terri was the only one privileged enough to go into the grocery store with my mother. Ever since my brother Bill knocked over that six-foot-tall display of spray starch, he and I were banned to the car. In Mother's defense, the grocery store manager was probably none too happy about having ninety cans of spray starch spewing out all at once.

Anyway, as the boredom of sitting in the car set in, my brother decided to jump into the front seat and pretend to drive. That lasted about fifteen or so minutes before he realized that the car seat actually moved forward and backward. And since we always had to park "Old Red" on an incline in case she needed pushing off, that made the seat an instant Disney ride, trailer park style. "Weeee, weeee!" Bill shouted as he moved the seat forward and backward, forward and backward, forward and backward. Now you may be asking yourself, why? I will tell you why. Because that is what ADD does all day long, 24/7. I kid you not.

And sure enough, on one of those trips backward, the entire car seat slid all the way off the tracks that were bolted to the floor, and that seat landed in the back on the floorboard.

"Oh, this can't be good, Billy," I said in disbelief, as my brother picked the front seat up out of the back-seat area.

Insert brother Bill's eyes wide open in fear.

I think this was the start of my "detective" style personality, for I was now in charge of the lookout. As Bill was frantically trying to get the seat back on the tracks, I was giving the play-by-play.

"She's third in line!" Bill was still trying to fix it, as Mother was waiting to unload her buggy.

"She's second in line!" I continued, as the sweat began to pour from my brother's forehead.

"She's unloading her buggy! Hurry, Bill!" Insert panic in us both.

"She's checking out! She's checking out!" I announced with a faster and faster beating heart.

But it was no use because that seat was not going back on those tracks any time soon. You know what ADD did next? Bill placed that seat on the top of those floor tracks, and we pretended like nothing happened. We would just fix it when we got home. And that plan would have worked too if Mother hadn't jumped into the car like she was Tarzan swinging in off a vine. Yep, my mother and her car seat flipped over into the back, right on top of us. "Billy, what did you do to my chair?" she yelled. Notice that she said Billy? 'Cause she knew this is what happens when you leave ADD unattended.

Let me tell you about that ride home. Mother propped that seat up on top of those tracks, and Bill had to hold it in place, all the way

back to the trailer park. When my mother would push down on the clutch to change the gears, she would slide toward the back seat, and then brother Bill, well, he would push her all the way back up to the front. And when Mother went around those curves, Bill would have to hold that seat down to keep her from falling over because that chair was flopping all over the place. It was a long ride home. Several times during the trip, when Mother couldn't contain her anger anymore, she would hold onto the stirring wheel with one hand and swat my brother on the head several times with a backhanded move using the other hand. Then Bill would have to push her back to the front again. "Mom, stop hitting me. I can't hold the chair if you're hitting me in the head," declared my brother.

As with any car, time takes its toll, and "Old Red" became faded. My uncle decided he would help us out since we didn't have the money to paint her. The company he worked for had some leftover paint, and he could use it. Only problem with this free paint plan was the paint was orange—yep, bright orange. It was humbling, to say the least, but if you are living in a trailer park, a bright orange car that looks like a piece of fruit on wheels is the least of your worries.

"Old Red" increasingly became more and more difficult to crank. It seemed like every time we wanted to drive it, we had to push her off first. Bill and I would push while Mother would pop the clutch until it cranked. Sister Terri would be lying down in the seat in total embarrassment, especially when we would have to pick Bill up from football practice. It's hard to be cool if you have to ask some of the cool kids to help you push your car out of the parking lot.

We had a neighbor that swore up and down to my daddy that he could take a Volkswagen apart and put it back together with ease. And Dad let him take "Old Red" apart. It turned out that man lied. "You take your dang tools and get the heck out of my yard!" Dad ordered. Of course, those were not the exact words my daddy used, but you get the picture. I do believe the only reason that man made it out of the yard alive was the fact he was a navy man and my dad was too.

After that, "Old Red" was never the same again. In 1984, Mother just about had to pay someone to take her off our hands. She was with us through a lot of hard times. RIP, "Old Red," RIP.

Brother Bill Meets Jesus

I was reminded the other day about the time my mother, sister, and brother went out west with my two uncles and their families. I did not make this trip because I was already in college trying to become a nurse/FBI agent/nurse/DEA/nurse/forensic expert. And besides, I went the previous year with my aunt, uncle, and cousins. Anyway, back to my story.

On this trip, they set out to see the Royal Gorge. Not only see it but also to ride the tramcar across that big opening in the ground. My motto has always been: "Shoot yeah! I'll try anything once." And that motto still holds true today with the exceptions of skydiving, going into space, or riding in one of those submarines deep into the ocean. Nope, not a chance on those. And if you see me doing any of those stupid things, chances are I am drunk or have lost my ever-loving mind, so please stop me.

This brings me back to that tramcar traveling on that tiny wire stretched out across that big hole. Unless Jesus is standing on the other side telling me that wire is the only way to get into heaven, I ain't getting on that thing. But my family did. I think it was a case of just not knowing any better.

Mother said, just as soon as that tiny car dropped off the side of that mountain and before the wire caught hold of it, my brother hit his knees. Yep, something along the lines of a one-man tent revival. As Bill commenced to preaching the Word of God, my mother commenced to making him stop by popping him on the head. The *Jerry Springer Show* had nothing on us, people. Let's just say if that incident had happened in the present times, my brother Bill would have been tackled to the ground by US Marshalls, handcuffed, dressed in

his new white jacket, and sent off to be evaluated by somebody with a bunch of letters behind their name. But since this was in the days before the government got involved with raising our kids, my mom just swatted him a few times while shouting, "Boy, get your butt off that floor and stop that racket!" I can only imagine what the other vacationers thought of this trailer park intervention. Can't you just see them looking around for Jesus to appear out of thin air 'cause Bill was determined to have Him inside that tiny car with them?

Once that thing made it across to the other side, Bill crawled out and refused to get back inside. In all honesty, I bet the other tram passengers threw them out and closed the door. I can hear them now saying, "Those people are crazy and not getting back in here with us. Close the door and get this thing going." Although Bill's problem of riding that thing back across seemed to be solved, another problem appeared. They were now stuck on the other side of this gigantic hole. Mother said it was like walking through uncharted wilderness. That's right—briars, creatures, darkness, trees, branches, and all things scary. The plan was to go two miles to the bridge and walk back across. This sounded good at the time, but my cousin, Jennifer, said the bridge was in the midst of repairs and the winds made walking across that thing nearly impossible.

She just knew, at any moment, they were going to be flung off the bridge and into the air. She swears to this day the boards were not nailed down and made wave motions as they traveled back across. Not only did they have to deal with the moving boards but also every so many steps they could see all the way down to the tiny river below. Needless to say, it was the last vacation out west for the trailer park crowd.

And Then There Were Two Babies

I think it should be a law when you leave the hospital with a baby boy that there should be some kind of written instructions. At the very least, they should give new mothers the number to an emergency hotline for raising boys. Oh sure, they have a mother's heart and all, but they are just so, for lack of a better word, interesting to raise. Now I am not talking about the expected stuff like dirty clothes, dead bugs in pants pocket, the excessive supply of Band-Aids, or the overwhelming need for air fresheners. I'm talking about how their little minds work.

Take for instance the day I brought home my second born child—the girl. Granted there was only fifteen months between my two blessings, so I knew it may be a long row to hoe, but nothing prepared me for what lay ahead. Try explaining to a fifteen-month-old, "Son, you cannot eat her!"

I had this new baby home for less than one day, and I was already having second thoughts. She did not like having her toe bitten, not one bit. Me either! How do I explain this? Also just because someone brings the new baby a toy, it is best not to throw it into the playpen.

"Son, do not hit the new baby in the head."

As we are all standing there, waiting for the goose egg to appear, I found myself telling that crying baby, "Just shake it off, sister, man up! Your momma is not going to jail."

Oh, and let's just give thanks to the good Lord that the baby swing had some kind of safety feature that prevented the child from making a full circle all the way around. She did not like that either, and I thought my heart stopped beating for a few seconds. It only took once before I was scratching baby swing off the list of daily activities.

Since my entire baby stuff was still new, my church family gave me a "diapers and casserole" shower. I came away from that shower with many, many packs of diapers. By the time the second child came along, we had only been married two years and had not yet come into our millions like you expect to when you are young and stupid. Anyway, the diapers were well needed. Every time I changed one of them young'uns, I could feel the household debt rise. Imagine my surprise when I entered my son's room to find he had opened every one of those packs of diapers and taped them to the walls. If you do not know, once the diaper tape has been used, say like in an artistic display on a wall, they will not stick again. For the first six months of my daughter's life, she wore diapers with duct tape holding them on. I kid you not.

The first few years are still a blur. There were many, many calls to the poison control center. You know that you have made an impression on the medical community when the doctor's office actually calls you out of the blue saying, "You remember when Eli did such and such? What did we do for that?"

Now you might ask why they didn't just look it up on his chart. If you had seen his chart, you would know why. It is just slightly smaller than a set of encyclopedias. Just for the record, if your little boy crawls behind the washing machine and drinks the water out of the hose, it will be okay. Fingernail polish placed on little boy's eyelashes just has to wear itself off. If you lose your car keys, check the diaper. And if your little artist decides to put crayons into the dryer when you are not looking, you will survive wearing those multicolored clothes whether you like it or not. I bet you didn't know that the toilet bowl cleaner that turns the water blue in the toilet bowl looks just like Kool-Aid to little boys. If you happen to be in another room and hear toddlers smacking their little lips together followed by "Mmm," run and take the little tea set spoons away. And if your pediatricians insist that you stop using it, don't switch to the little cake things that hang over the side of the bowl. Those appear to look like cookies, and your pediatrician will not be happy with that either. I told the doctor after that visit to just take them and raise them himself. It is a thousand wonders that man did not report me to some

kind of state agency. Ropes of any kind are a no-no. No matter how important playing cowboys and Indians are to little southern boys, try explaining to your friends and family how your precious little girl got that rope burn across her neck. Speaking of cowboys and Indians, plastic BB guns for little boys should be outlawed. Even if you take the plastic BBs away, little boys will find something to shoot out of that gun. Ever been shot with a tinker toy? Not as fun as one might think. And lastly, if you find your little baby girl sitting pretty on the floor covered from head to toe with Tide laundry soap, do not put said child in a tub full of water. You will have trouble picking her up out of the tub full of bubbles. And she will not like it one bit.

The Coloring

Early on in raising my kids, I knew I would never get the mother-of-the-year award. Let's just say if you ever have to peel your crawling toddler off your kitchen floor because she is stuck in a half gallon of syrup, you tend to reset your goals. Let me stop here and explain. While I was running in and out of the kitchen door helping my husband fix a water leak I caused, the son was busy pouring out the syrup. Well, I kind of caused it. You see, our hand-me-down lawn mower was broken, and this passerby had stopped and asked if he could mow our grass. Shoot yeah! Grass—this term used loosely here because I actually think it could have been cut and baled for hay.

Anyway, back to the story. My new yardman had been on the job less than twenty minutes, when his lawn mower ran over a water valve and caused a giant waterspout in my yard. Our house, at this time, was handed down from my husband's grandparents and not surprising did not have a shut-off valve to that waterline. So long story short, I had to call the husband from work, and he had to rerun the waterlines. It took my husband all day to rerun those lines only stopping briefly when the new yardman asked for money. Let's just say that was the last time I was in charge of hiring anyone. I tell you all that to tell you about the syrup. Can you just imagine how sticky a toddler is when stuck to the floor of a house with no water and one wet wipe? By the time that day was over, everything on me, my son, and my daughter was sticky.

I remember my mother saying, "Have your children close together because they will love each other." Yeah, I think she lied. Never more obvious than the day my two-year-old son took a black Sharpie and colored his little sister. Yep, the only thing left on her

untouched by the Sharpie was the few teeth she had and her eyeballs. I cried and cried, vowing to not leave the house until she was white again. I should stop here and say if you try scrubbing black Sharpie off your child's body, it will only begin to look like purple bruises. It is best to just leave it alone. And by the afternoon, I had accepted defeat. She was going to have to just stay that way, which would have been just fine if she had not tried to eat a light bulb. Now granted we had all kinds of kid-size snacks in the house, but no, the Ninja Turtle flashlight bulb belonging to my son must have looked more appealing. Folks, it was not my finest hour having to explain to my children's doctor why I could not bring my daughter in to see him that day, and if he could just tell me how to fix her bleeding lip, all would be okay. "But, but, my son colored her today," I unwillingly confessed. Even with my tears, he insisted on checking out her lip.

So there we sat, in the crowded waiting room, amidst the staring eyes of all the other mothers. Honestly, I kept thinking social services was going to burst through the doors at any given minute. We finally made it in to see the doctor, the very doctor that had helped raise me up. Let's just say he was speechless. To make matters even worse, he sent us over to another place to get x-rays. Yep, a whole other waiting room full of people who thought I was unfit to be a parent. I couldn't really blame them, though. She was purple and black and still bleeding just a little.

Let's just say before this doctor retired and before I got them hooligans raised up, this trip would turn out to be one of the least embarrassing visits of all. I kid you not.

The New Mrs. Watton

You know the saying "You can't take the country out of someone?" Well, it works both ways, I tell you.

Today, at the lunch table, I was sitting across from my daughter, Rebekah, and I remembered something from the past—well, to be more specific, the farm. Yep, the hubby had the idea to move my city self to the country. Somehow, he talked me into it because, well frankly, I had two small children and not enough sleep, and I was stupid. Let's just say you learn things out there on the farm that you don't learn in books.

Take for instance, the very first night in that farmhouse. Now granted, I had taken extra care and concern in making the kids' new bedrooms look just like the ones they were used to at the city house. Yep, we even painted the rooms the same color and all. It was going be awesome. We were going to learn country. We had raised the windows up during the day 'cause being in the country, you could, and besides, we had a hundred and so acres and didn't have to worry about neighbors. Now pull up a chair. Here is lesson number one. As nightfall approached on our little farmhouse, we began to hear this loud animal sound. In fact, it was more like a thousand animal sounds. So the kids and I are huddled together in the center of the new den, waiting on my husband to get home.

"Mommy, what is that?" the children asked.

Quite frankly, I did not know, and I told the kids, "Don't anybody move. Maybe it will leave."

In my defense, who knew frogs could make those kinds of sounds? I think here was the beginning of my addiction to Tylenol PM. The kids finally went on to sleep. I, on the other hand, did not.

For lesson number two, let's talk about cats. City cats and barn cats are not the same creatures. To city cats, you say stuff like, "Here, kitty, kitty." To barn cats, you use words like, "Oh my god, call the priest! This thing is possessed." A fact we learned quickly when we gave sweet little Rebekah a newborn baby chicken. Our goal was to teach the kids responsibility, and we were going to raise our own eggs too, 'cause we were farmers and that's what farmers did, right? Imagine our horror as that big old yellow barn cat swiped that little darling off the palm of my three-year-old's hand. Insert screams from all who witnessed the horrific incident.

"Everybody, in the house now!" I screamed in horror. It took a few days before the hubby convinced us it was okay to go outside again.

We finally got enough of those sweet little chickens raised up to start getting eggs. Only no matter how much laying pellets I fed those things or how many cracked shells I put out for them to eat, not one egg—not one! Those things were as big as small dogs, I tell you. Every day, we took our shiny egg bucket down to the barn, and every day, we would come back empty-handed. Finally, I asked my neighbor down the road to stop by and tell me what I needed to do. He looked my chickens over good. Said I had the nicest-looking nest and the chicken pen was a good one. There was only one small problem he could see. "You ain't ever gonna get an egg out of them things. They be roosters."

Yep, fifteen of the finest-looking roosters ever. This brings me to lesson number three. "Mommy, what are they doing to our chickens?" my kids asked as they looked out the window. I felt the children were too young to explain dumplings.

Growing Cows

You know, to be a cattle farmer, well, you got to have cows. And sure enough, we started going to the stockyard. Before long, we got ourselves a couple of good ones and a bull. Yes, sir, we were in business now, going to make millions. However, it turned out to be hard work growing cows. Most of that work came from keeping them inside the pasture. I am ashamed to admit the cows learned faster than I did when it came to that electric fence. I could almost hear those cows saying every time I forgot, "Elsie, she touched it again."

The kids and I would hop in our golf cart and ride out to the pasture to feed our cows. Did you know cows are creatures of habit and our downfall turned out to be taking the golf cart? Every time we climbed into that golf cart, the cows thought it was time to eat even if it was not. I bet you didn't know it is actually scary to be chased down by stampede of cows.

"Faster, Mommy, faster! They gonna get us!" my kids yelled. And this was just when we were getting the hang of being farmers. Another thing we learned is it is best not to name them. Yep, we had one cow named Betsy that got sick, and after a good deal of coaching, I finally got her into the barn stall. Let me stop the story here to say that turned out not to be a good idea. She may have wobbled in there, but that ain't how she left. Anyway, back to the story. I nursed old Betsy for several days with a big plastic bottle, but she finally stopped taking it. Of course, I did what I always did and called on my neighbor to stop by and take a look. He looked at old Betsy and then looked at me and then looked at Betsy again and said, "You do know she is dead, right?"

Well, no, but that does explain a few things. Since I didn't really know the proper etiquette in cow funerals, I asked, "Well, what do I do now?"

"Get you a shovel," he said.

It took me almost all day to figure this one out, but before my husband got home, I did. Imagine the surprised look on his face when I handed him the shovel while informing him I had divided up the cattle. My cow was in the pasture, and his half of the herd was down at the barn.

With the herd growing rapidly, we were regulars at the stock-yard. One Saturday, we stumbled across this precious little baby calf. Apparently, it had lost its momma, and she needed us. We'd wake up before dawn and head down to the barn to bottle-feed this baby three times a day. Before long, our baby was gaining weight, gaining and gaining and gaining. Soon, it was nearing three hundred pounds.

In my defense, I'd like to add, I had no idea there was such a thing as midget cows. You may be able to get them to three hundred pounds, but they still gonna be only knee high. Yep, we got a few looks when we hauled her back to the stockyard. You know I figured out why country folks use words like *ain't* and *yep*. They're just too dang tired to be fancy.

Meanwhile Down at the Barn

There are many, many things that go on down at the barn, mostly things that city folks could never imagine in all their wildest dreams. Being new to the country way of life, the barn was full of learning. For starters, there are always going to be rats in the feed room—always. And they will never ever look like anything you see on the *Tom and Jerry Show*. The previous owners left their orange tabby cat in the barn. How do you leave your kitty cat behind? Who does that? I tell you who does that—scared people. Yes, sir, it didn't take us long to have a clear understanding of barn cats. We renamed that little darling Amityville Horror within the first week. Yeah, I think it would have taken a priest and a few gallons of holy water to run that cat off.

Next on our list of learning country was to always look down before stepping out of the truck. And I am not talking about stepping into what the cows left behind either. For some reason, snakes liked the barn too. Well, at least the really big ones did. I think the cat ate the little ones. Another thing you pick up on quickly at the barn is that yellow jackets love, love, love hay bales. And for all you city folks out there, a can of Off! insect spray will not prevent them from stinging. You actually need fire and gasoline to get those things out of the barn. I should stop and add here that there is a very thin line between getting rid of yellow jackets and actually burning the barn to the ground—just saying, a very thin line. Something else to note is no matter how convincing those boys are down at the feedstore, a family of four cannot ever eat four acres of corn. Oh, and if you decide to grow your own eggs, make sure you leave the feedstore with girl chickens and not boy ones. Unless there is some

major advancement in growing chickens that I do not know about, roosters will never lay eggs. It is best not to waste six months trying.

This brings me to why I wanted to talk about the barn in the first place. Before we knew what hit us, we had animals running out our ears. I guess the city folks thought we didn't have anything better to do than to keep the animals they did not want anymore. That's right. We had dogs, horses, chickens, cows, and goats. Let me stop here and tell you about goats. They eat everything under the sun, right down to the string off your fishing poles if you leave them out and propped up next to the barn. One of our precious little darlings also was fond of standing on top of cars, especially new vehicles that just rolled off the dealership parking lot. Yeah, try apologizing to the new car owner about that. "Well, at least you still got the new car scent. Would you like one of our cows?" we said. All these animals were fine with the husband because we could raise and sell these things. Insert rolling eyes here.

Everything was going along just fine until we headed to the stockyard one Saturday morning and came back home with a big old pig—a soon-to-be mama pig, to be exact. And the pig learning began. For starters, mama pigs are meaner than a rattlesnake when it comes to their babies. We loved on those pigs—from a far, from a very, very far. Those things grew and grew and grew. Soon, it was time for them to leave our farm. And when it came time to load them up in the cattle trailer, there are two things you should know. First, it will take an army of very brave men. And secondly, you will need to remove all, and I do mean all, the animals out of the barn. I actually thought I heard the cat say, "We need to get the heck out of here!" Before we finally got that rascal in the cattle trailer, we had animals slung all over the place. I think the kids ran all the way back to the house to pack their bags. They were heading back to the city. Now, everybody, sit down for a very important lesson. It is very important that you latch down the door on the cattle trailer very quickly after you get the pig inside there. Because if you don't, that mean thing will knock you over coming back out. Insert husband on the ground and the mama pig back in the stall where she started. I am not sure

how long it took me to come out of shock. I had mud on me where there had never been mud before.

You want to know what we did next? We rounded up all the casualties and headed to the veterinarian's office. I bet when that doctor woke up that morning, she had no idea what lied ahead. This was a brand-new clinic, and thanks to our animals, we were easily paying their first six-month's rent. I remember the vet saying, "I don't think I have ever had anyone bring their dogs in a cattle trailer before." She had to sit down and prioritize what to actually tend to first.

I looked over at her and said, "Excuse my hair, I usually don't accessorize with cow pasture. By the way, is anybody working next weekend? 'Cause either me or that pig is leaving the farm."

So the next time you walk by the bacon in the grocery store, remember this: there is a farmer somewhere that took one for the team. Pig farming—not for sissies.

Lil' Ski Bunny

A long, long time ago, our Sunday school class took a trip out West to ski. At first, we were a little hesitant, but this venture turned out to become a new family tradition. It's a whole new world out there, and well, as bad as the hubby and I were at skiing, we were determined to introduce that world to our kids. Each year, we would set aside money, and by December, we would have enough to head out West. Well, let me back up a little. If we took the camper, packed it with our own food and snacks, then we would have enough money to ski. And ski we did.

It didn't take long to realize the son was a natural on the slopes. The daughter, on the other hand, well, let's just say she was a regular at the ski school. Actually to be fair, the skiing she accomplished, it was the lift that defeated her every time. In fact, the family would draw straws to see who had to ride up the mountain with her. Now don't get me wrong, I love my daughter dearly, but that child can make a peaceful, scenic lift trip up a majestic mountainside feel like a flying trip through Hades. For starters, we never made it up the mountain with all our equipment, and dismounting off that chair with her, well, let's just say it was a miracle we all survived. Until you can dismount out of a lift chair, with a screaming child wrapped around your neck, two sets of skis flying through the air, and land yourself into a complete split that would make any gymnast envious, then you got nothing on me, people. Sometimes, we would receive a round of applause from the lift workers, but mostly, they were too busy clearing the landing area in anticipation of our next arrival.

Take for instance our first visit to New Mexico's slopes. The entire place was just beautiful. The grounds were covered with new snow. The crisp air was flowing through our bodies. The ski condi-

33

tions were just perfect and could not have been any better. I headed to the lift line with daughter in tow. I have to say, she always looked cute as a button and always so confident that this ride would be her best ever. All the way up through the line, she was practicing. And as the chair was coming up behind us, she bent her knees just perfectly. And in we went. Well, in I went. She, on the other hand, slipped off the chair and was twirling circles on the ground below as I was heading up the mountainside. Panic! Clearly, if all the brain cells had been given adequate time to vote on this scenario, I would probably not have been flying through the air like some kind of superhero. Let me stop here and say, just because you see it in the movies does not mean you should try it at home. But then again, I was a momma, and there was no way I was leaving my baby behind.

I dropped out of that chair like a yard dart was being tossed from the heavens—not my finest hour. Soon, I was surrounded by all kind of ski patrol staff. Let me just say, I may not have understood the language, but I got the jest of what they were saying. They plucked me out of that snow and gathered up all my stuff. At this point, all you can do is dust the snow off your hiney, put your shades back on, grab your little girl's hand, and walk away.

You know, even when we finally made it up the mountain, skiing back down had its own set of problems as well. As you travel back down the mountainside, it is common practice to give a heads-up to the skiers you may pass along the way. And well, I could hear my little skier calling out, "Right side. No, left side. No, right side."

The closer she got, I could hear the panic in her voice, and with one final yell, she said, "Move, Mom!" Now granted, this slope was as wide as a four-lane highway, so passing was usually no problem. The next thing I knew, I was laid out flat, looking up into the blue skies, hearing the people on the passing lift overhead, "Did you see that?"

I'm not really sure how long it was until I concluded my vision was okay and, in fact, was really looking at two sets of skis sticking up from my feet. One set belonged to me; the other, to my daughter who was lying underneath my body. I rolled over, plucked her out of the snow, and headed to the lodge.

"Come on, dear. I think your momma is going to take up drinking."

Emergency Rooms

Back when I was growing up, you did not go to the ER unless the bone was sticking out or you could not stop the bleeding. There may be one or two more reasons others may get to take a trip into the fast-moving world of modern medicine but not us in the trailer park. Mother and I were having a little walk down memory lane one afternoon, when she recalls, "I remember when you were little and we had to take you to the emergency room. You had strep throat, and the nurse at the doctor's office gave you one of those penicillin shots. You turned blue after that. I believe they said you were allergic to them."

Folks, I was entering middle age when she shared this little bit of information. Insert rolling eyes and jaw dropping to the ground. It is a thousand wonders I survived my childhood.

"Mother! I don't think you outgrow being allergic to penicillin," I informed her.

You have not lived until you have to make a call to the pediatric clinic and ask them to pull your chart and then let the nurse know you were born in the 1960s. Insert silence on the phone.

"Listen, sweetheart," I stated. "One of us is going have to pull my chart. If I need to make an appointment with the doctor, then give the phone over to the receptionist right now. Tell that pediatrician to brush up on high blood pressure and hot flashes. I will see him next week."

One of our classic trips to the emergency room was when my ADD husband decided to use a pocketknife as a screwdriver. My son absolutely loved the song "Every Light in the House" sung by Trace Adkins. The singer was going to be the entertainment at the Dixie National Rodeo, and we got tickets. Insert my husband buying one

of those stuffed animals for my daughter at the concession stand. All he needed to do was put the batteries in it—hence the reason for him breaking out the pocketknife. Call it woman's intuition if you will, but I knew before he got that knife out of his pocket, we would be buying Band-Aids somewhere. And we did. Insert massive blood loss and having to have security calling for the paramedics. Lucky for us, we got to get our Band-Aids from the local emergency room downtown. I don't know if you should call it country gone to town or what, but that big city emergency room was scary, especially when there had just been a big shooting and the suspect decided to finish the job right there in the ER. Somewhere between the police storming in and the kids clinging to my legs for safety, the student doctor got my husband all stitched up, and we got were able to get out of that place intact. I would like to say our night ended here, but it did not. We had just sat back down in our seats at the rodeo when the new doctor's work of art failed. Security reintroduced us again to the paramedics. After that second trip to the emergency room, my kids just wanted to go home and put the nightmare behind them. We never did get to see Trace.

Now I tell you all that to tell you this. With the exception of the abovementioned chaos, it seems like the only times we have to go to the ER is when we look like we have been in the pea patch all day. The day my husband decided to catch his own Adam's apple with a nine-inch Rapala fishing lure, I think I was in flip-flops. Then there was the time we had to take Rebekah to the Immediate Care Clinic. My husband had spent all day painting the fence. I cannot remember now what was wrong with that child, but the doctor at that clinic sent us right on over to the ER. Insert a very long night in a crowded waiting room with a husband wearing cut-off pajama pants and a white T-shirt with no less than seven holes. If you think that image could not be any worse, he was wearing his work boots too. In his defense, I had told him he could just sit in the car at the clinic. I never dreamed we would end up with an emergency room visit.

We eased our way into the crowded waiting room and luckily found a group of empty seats. Fifteen minutes into our wait, we understood why those seats were vacant.

"Mom, why is that man staring at you?" my daughter asked.

It did not take much longer to figure it out. He was staring at my soul, deep into my soul, as though he needed to put it in a jar somewhere.

Since my sister is of the Catholic faith, I leaned over and whispered into my child's ear, "If my head starts spinning, call your Aunt Terri and see if she has that priest on speed dial."

Rebekah decided to pass the time with sleeping. I was too scared to close my eyes, though. I just knew at any moment, the prom king and queen were going to arrive and that demon-processed thing across from me was fixing to set these walls on fire with his mind.

To make matters worse, while I was reciting the Lord's Prayer, my husband was dealing with a demon of another kind. The five-hundred-pound, non-bathing beauty sitting across from him had decided he was her kind of man. And that miniskirt she was sporting wouldn't even cover her panties. I guess this was the reason she chose not to put them on. But hey, I am not judging. Every time she moved, my husband grabbed onto the chair handles.

"Honey, I do believe she is going to sling me over her shoulders just any minute now," my husband said.

As much as I loved that man, I was just going to have to let her take him on home. I was busy trying to remember enough Scripture to keep this waiting room from going up in flames.

Just before my husband fled the room, I woke my daughter up.

"Listen, if your daddy has his pocketknife and you are willing to take one for the team, I believe I can get your chart moved up to the front of the line and we can get the heck out of here." She declined.

Camping

Some of the best memories my family have are our camping trips. If you want your kids to enjoy God's country, you best get yourself a camper. Our first camper only cost us about four thousand dollars or so. It was old and little, but it was clean and had a bathroom and a kitchen. We loved that camper dearly and went all over this country in that thing. Before we actually got rid of that camper, it was being held together by duct tape and sheet and metal screws. I kid you not.

One of the best parts of camping was traveling with my cousins. I remember the first time we took our campers to the mountains to let our kids learn to ski. Keep in mind, the traveling was part of the fun. And if you think stopping and changing flat tires about every six hundred miles is fun, then you would love camping with us. Something was always breaking down on our little camper. Whether it was the tires, the waterlines, or, heaven forbid, the septic tank, my husband was always working on that thing—hence the reasons for so much duct tape and metal screws.

We started packing our camper weeks before that chance-of-a-lifetime event. We had our campground reserved and our route all planned out. To keep the cost down, we would pack our own food and snacks and stop somewhere on the side of the road along the way to eat our meals. The day finally arrived, and this bunch headed to the mountains. But the closer we got to this place, we began to have a little concern. One of the kids said, "I don't see any snow, Momma."

And you know what? There wasn't any. Insert my husband making a phone call to the campground staff. Now we had carefully chosen the campground closest to the ski resort, so there must be snow, right? The campground staff assured us they had snow and plenty.

Turned out that may have been a little "white" lie, because when we finally arrived, they didn't have one flake of snow anywhere on that entire place. And surprisingly, that turned out to be the very least of our troubles.

For starters, this sweet little place was miles off the interstate. In fact, we ran out of concrete and blacktop long before we actually got there. Yep, we got down to the gravel roads, which resulted in another call to the campground staff. To say this place was not easy on the eyes would have been an understatement, but we were tired and certainly needed to get those young'uns out of our vehicles. As we approached the campground office/pool hall/personal house and dog breeding facility, we were greeted by four of the biggest and meanest pit bull dogs known to mankind. And not surprisingly, they took an immediate disliking to us.

The staff hollered out through the screen porch, "Y'all come on inside. They not gonna bite."

Now I could be wrong, but them little darlings were acting like they had not eaten all week, and I wasn't going to be their reintroduction back into the food chain. I told her, "Ma'am, you are going to have to take Precious, T-Bone, Killer, and Cujo somewhere else or we are getting back in our trucks and leaving."

I would like to state for the record that before this adventure was over, those little darlings turned out to be the least of our troubles.

And through the screen door, our campground hostess yelled, "Y'all come on inside. My son, (let's just call him, Chester, for all intents and purposes), will take 'em on to the back."

Because we could actually hear those dogs chewing through the doors, we entered cautiously into the office/lobby/pool hall/living room combination.

"We have reservations," my husband said.

Before we could proceed further with our conversation, the lady of the house reached and flipped the top on their tiny music box located on the customer service counter. Yes, sir, we stood there, just looking at each other, listening to all the verses of their campground theme song blaring from that tiny music box. Folks, I thought my

husband's head was going to explode because he still wanted to speak to the genius who thought this place was covered in snow.

After the concert was completed, a special invitation was extended to our kids for a friendly game of pool with their son Chester. I am almost certain Chester had already made it to some type of government watch list by now.

"Y'all let them kids come up here and play with Chester anytime," the woman said.

I cannot actually even recall what town this campground was in and certainly cannot recall the staff's names or even the name of the campground. My husband finally got to ask his long-awaited question.

"Ma'am, could you point to the snow because I am having a little trouble seeing it." Insert tour of the facility.

"Y'all come on and follow me," said our hostess as she led us down the darkened hallway. Keep in mind, I am sure the dogs were getting close to a breakout at this point, and the boys and I quietly left the line to join the girls who hauled tail back to the truck moments earlier.

Now there were two reasons for not going down that dark hallway. First, I needed to see if we had cell phone service. And secondly, if we were fixing to turn up missing, they were going to have to work for it. Besides, my son was in a slight state of shock.

"Mom, I don't want to play with Chester. He scary." Insert a brief but thorough discussion on "stranger-danger."

Meanwhile, back at the tour, my husband, cousin, and cousin's husband were being escorted into the girl's bathroom to a tiny window.

"Y'all look over thar," said the gracious hostess as she pointed to the next mountaintop about ten miles as the crow flies. "The snow is over thar," she explained.

Now as fun as all that was, the real fun was just getting started. There was not two feet anywhere on this entire campground that was level. The men walked around this place scratching their heads, trying to figure out just how to keep those campers from sliding off the side of this mountain.

"Did you bring any concrete blocks?" one of them asked the other.

It took some engineering before we were able to lay our heads down to go to sleep. My final words that night were, "Lord, keep us safe while we are skiing tomorrow, protect us from those dogs and Chester. And if we don't meet you during the night when this camper slides off this mountain while we're sleeping, I'll talk to you in the morning."

I Can't Believe That Just Happened

Have you ever found yourself happily going through life and then walking right into something stupid? You know, one minute everything is great, and the next your hands are on your hips and you are hollering out, "Seriously? I can't believe that just happened."

Take for instance the time I had to fly out west with a big group of my church friends. I had only flown twice when I was little, and I really could not remember anything about it. I had prayed to God for weeks beforehand not to let me be that idiot on the plane that loses her mind when she starts thinking about just how on earth is this thing staying in the air. I knew once I got to thinking about the mechanics of a big plane, flying through the air with absolutely nothing really holding it up, I would be security's worst nightmare. Now just to prove once again how God takes care of answering prayers, in my big group of skiers was a counselor who worked at the local mental health facility and specialized in helping people with their fears.

Not only that, his wife was an RN. I'll have you know, my husband sat me right next to them on that plane. I think I heard him say something to those folks about, "She is yours until this plane gets back on the ground." I would like to think he was just worried about my health, but in reality, he did not want to be anywhere near when security had to take me down. After all that worrying, I'll also have you know my new mental health counselor and his RN helped me make it through that flight just fine. I was so proud of myself and so thankful God had sent those folks to be part of my church family.

What I didn't take into consideration was what happened next on that shuttle bus up the mountainside. I parked my hiney in the front seat so I could get a good look at this unseen world. But between

the diesel exhaust fumes coming from the bus engine and the curvy roads going up that mountainside, I soon found that the plane ride was the least of my worries. When that bus finally came to a stop, I crawled off it on my hands and knees, and I laid out right there at the bottom step, face down in the snow like I was waiting on the crime scene people to show up and draw the chalk line around my body. No matter how much my now embarrassed husband begged, I was not moving until the paramedics put me on the stretcher or God took me on to heaven, whichever came first, it did not matter to me. Finally, when everyone realized I was not going to budge, they began to exit, taking giant leaps into the air and over my body. I am not sure how long it took. I eventually was able to raise my head off the ground and made my way to a bed where I remained until the next morning. I believe the locals called it altitude sickness, something we in Mississippi did not even know existed. I will take hurricanes and hot summers any day. Those folks out west can keep their altitude sickness all to themselves. Thankfully for me, my friends let me join back into the group the next morning, and we ended up having a great time skiing.

Years later, we moved to another county and started attending a new church. The old church was still close enough, though, to visit from time to time, and we did. A memory from one Sunday visit still brings a great deal of laughter to us all. First, let me say that when you grow up without a lot of money, you cherish hand-me-down clothes. We still do to this day. My sister's husband had some shirts he handed down to us. They were already ironed and ready to wear, so on this particular Sunday, my husband grabbed one out of our closet, and we headed off to see our beloved church family. One by one, we were greeted with handshakes and hugs, and we took our place in the pew. Before long, the singing and preaching was all over, and we made our way back through all the handshakes and hugs all the way to the car. This is when the day turned bad, for on the way to the restaurant, my husband becomes aware of a sticker that was stuck to the lower back of his shirt. No matter how much he tried while driving, he could not get it pulled off. Insert us standing in the parking lot of the new Chili's restaurant.

"Can you see it?" he asked as he turned his backside around to me.

Yeah, I can see it all right, but the problem was, should I tell him just what I saw?

Let me stop right here and tell you this. One of my sister's five kids had found her box of—how do I say this politely? Hmmm—well, there is just no other way but to come right out and say it. One of those young'uns had found her box of Carefree mini pads and had stuck them all over her house—including the back of my husband's new hand-me-down shirt that had been placed with the other hand-me-down clothes on her dining room table, waiting on me to pick them up. My apologies if that offends anyone. Let me tell you, it was like a tent revival gone wrong. Apparently, wearing a mini pad on your shirt to church will make you lose your "man card," and my husband feared his was gone for good.

Speaking of church, ever since Rebekah was a little girl, I took her with me to baby showers, weddings, and visiting folks in the hospital. When she got old enough, she would even bake cookies when we took meals to the sick. I felt it was my responsibility to teach her how to be a young lady, helping with the needs of the church.

I remember one time when we set out to invite a family to church, and it just so happened that this lady cut hair for a living. Insert my daughter hopping up in that salon chair to get her hair done while I carried on about how wonderful our church was and how we would love to have her and her family join us on Sunday. My daughter may have very well toted a picture of Brittney Spears into that place in hopes of looking like a pop star, but she came out looking like she had a fight with a Weed eater and lost.

If looks could have killed, I would have burst into flames on the way back home. She was done with sharing the Word of God. That haircut was beyond bad, and there was no way to fix it either. I must tell you, for the next month, my child had to wear little clips all over her head to keep the hair from sticking up. To this day, she still has nightmares about it.

For a few days now, my daughter has been racking her brains trying her best to come up with a mishap story about her brother, Eli.

She cannot. My daughter swears the crowd parts and the light from Heaven shines down on my son with each step he takes. It is like he lives in a world of never-ending blessings of milk and honey and she lives in the land of bad hair days. After she finally gave up, she said, "Mom, it just isn't fair."

Katrina

All there was left to do was to paint it. Yep. We had finally saved up enough money to have our wooden fence built, not just the fence but the arbor too. It was beautiful. Slowly but surely, we were finishing our yard, one step at a time. The next thing on the long list was to take down the trees that were too close to the house. We marked these trees with bright orange tape.

When the final bids were in, the last one was ten thousand dollars. As the man handed me the piece of paper, I nodded and thanked him for his time. I then informed the kids, "One of you is not going to college." These trees had to come down, and we begin to save our money.

I'll have you know that within a couple of weeks, Hurricane Katrina took care of most of the trees in our yard, thirty-two of them to be exact. Unable to withstand the force of nature, one by one, the trees fell. The next morning, we stood on our porches assessing the damage. We had inadvertently discovered the only thing that could withstand the force of Mother Nature's wrath—it was bright orange tape. Yep. Every single tree that had orange tape on it was still standing. I kid you not. Those we wanted to keep were now lying on top of our new fence—well, what was left of that fence.

The company that was hired to clean up the mess in our yard had a foreman that spoke broken English. He asked my husband, "We come to cut trees with tape on them?" My husband explained that those were the trees we were taking bids on to cut down before the storm but the trees they were to take care of were the ones on the ground. The foreman scratched his head, looked at my husband, and laughed out loud. He was still laughing as he walked away to start his work.

Now do not get me wrong. We were blessed beyond what we deserved. My family was safe, and the house was still standing. The day after the storm, my sister had to take one of her babies to the emergency room. The child had pneumonia. From the hospital, Terri called in a panic and needed us to go find children's Tylenol and Motrin. As you can imagine, most all the businesses were closed, but we did find one grocery store that was going to open soon, and a line had begun to form. The manager had already told us that, one by one, an employee would walk the customers through the store using a flashlight and find what was needed. Then the employee would take the next person inside.

I first noticed him as he was making his way across the parking lot. He was a giant of a man, and by the way he strutted up to the store, I knew he was bad to the bone. Just as I figured he would do, he walked right up to the front of the line and waited. Insert my husband shouting at him from eight spaces back, "Back of the line, dude. Get to the back of the line."

My husband had lost his mind. I turned to him in horror and said, "Well, I hope you brought your slingshot!"

Clearly, I had not arrived to this grocery store with enough weaponry to take Goliath down. Insert quick look into my purse. Death by hairbrush was not going to be an option. As Goliath slowly turned his body around to accept my husband's challenge, you could have heard a pin drop. And that line we were standing in, well, it parted like the Red Sea.

Just as I was about to start shouting, "Somebody call 911!" the little lady two spaces up spoke, "I will cut you with my knife, boy, if you don't move to the back of this line."

She was all dressed up and looking like she had just come from prayer meeting. Game on, Goliath, game on. Let's just say the law had to be called and leave it at that.

I darted into that store, grabbed that medicine, and dropped a few dollars on the conveyer belt. "Keep the change!" I felt like it was going to take extra backup to get Goliath into that patrol car, and I had no intentions on waiting for them to arrive.

As you all know by now, I am married to the poster child for ADD. That being said, our generator "Ole Smoky" did not receive its pre-hurricane inspection, which surprises absolutely nobody. In fact, our generator was still attached to the bottom of an airboat somewhere in a warehouse downtown. It was not like we did not know this hurricane was coming. It was summertime in Mississippi, and I was hot. Let's just say, we had a little discussion about my being hot, and that did the trick.

When he finally got that thing cranked, you would have thought a 747 had landed in my backyard. Not only was it loud, but also, at any moment, I was sure the fire department was going to show up and try to shut it down. It took God Himself to keep that contraption working. You know how I know that? Because every time that generator stopped, I could hear my husband saying, "Help me, Jesus!" Let me just tell you that machine drank the gas. And it sounded like a tent revival was going on every time Chris had to siphon gas out of my big old car. Let's just say the next time the weatherman said anything about hurricanes, he filled up the gas cans.

My sister and I live in the same neighborhood. While I am sure the EPA was trying to find the source of the mysterious black cloud seeping through the ozone layer from my side of the lake, my sister had moved all her kids into their camper parked in her backyard. I was flushing toilets with lake water and cooking on the outside grill all the while my sister and mother were enjoying running water and a fully functionally kitchen.

We tried to attach "Ole Smoky" to our camper, but it simply did not have the strength. My family and my brother's family spent the next few days living in two rooms of our house and cooking outside on the grill. We feared "Ole Smoky" was going to give us lung disease, so we had to keep the windows shut tight. The small window unit my husband found was only big enough to cool one room. Insert polyethylene and duct tape. Since our house looked like were expecting a nuclear attack, my brother bought him a new generator and moved his family back to his house. I couldn't blame him, though. Now don't get me wrong. We were blessed, and we knew it.

It did not matter what you did for a living—doctor, lawyer, writer, or fisherman. Before this adventure was over, you had a clothesline strung up across your front porch, and you were bathing your kids in the lake. I remember my niece bringing me her towel back and saying, "Aunt Vicki, this towel is scratchy and smells like gas." Yeah, "Ole Smoky" gave a whole new meaning to the words *outdoor fresh*.

Meanwhile, down the street at the Luxury Camper, my mother and sister were making pound cakes. Her kids were handing out Ziploc bags with slices of homemade pound cakes to all the visiting service companies that had come to our rescue.

We may have had our underwear hanging on the front porch, and we may have been cooking our grits on the grill, but there were a few things to remember. In times of great need, we will share our resources, we will volunteer our skills, we will offer our sweat, and we will pray to our God.

We are caring, we are resourceful, and we are Southern.

Herding Chickens

I will need to give a little history in order for you to get the whole picture of this experience. We were headed out on one of our famous spring break vacations. Of course, for legal purposes, the state and location of said events will forevermore remain anonymous. Listen, I have enough enemies without adding an entire state to the list. Anyway, after we had been traveling a good part of the day and very late into the night, it was past time to let five teenagers and one grandmother out of the vehicle. As we pulled our tired bodies into the campground, we had no idea what the morning sunlight would do to our camping experience. In case you may not know, it is customary if you arrive very late at a campground to just park and take care of the registration business the next morning.

As always, the hubby was the first one up, and he usually headed out to find a cup of coffee and to take care of the registration card. Afterward, he decided to get a jumpstart on the day, making his way to the campground showers. Now remember my husband is the poster child for ADD, and unless it is dealing with his work, food, hunting, fishing, fishing tackle, or boats, he may not pick up on things as quickly as the rest of us. Case in point, he was in the midst of showering when he realized there were things touching his feet. Now the rest of us folks would not have gotten into the shower stall in the first place if the overhead light was not working, but to the husband, it was no big deal. He'd just shower in the dark. That is until he realized he was not alone in the shower. It turned out this particular shower doubled as the local ashtray, and he had just showered with about fifty cigarette butts. Nasty. I will give him one thing,

though. Before leaving that bathroom, he fixed the light problem for the rest of us campers.

Within minutes, he realized he had hit the jackpot, because at the edge of this very campground, he spotted a breakfast diner. There had never been anything that got in the way of him and his meals until now. As he quietly strolled through the sparsely filled campground, he began to sense something was not quite right, but remember ADD, folks. With each step of the way, he noticed people appearing out of thin air. There were some popping up from behind the trees, others were peeping over cars and squatting from behind bushes, and a few were peeping through window curtains. Even as creepy as this may have been, he continued on to the diner anyway. In fact, it would be at the diner before the brain cells put it all together. Let me get you through his breakfast first.

In he walked and was greeted by the friendliest folks ever.

"How you doing, honey? Welcome. What you having, dear?" the waitresses greeted him.

He is in heaven. For the rest of us, we probably would have already noticed by now; he was the only one in this place with teeth. But then again, it was mealtime, and nothing got in the way of that until he walked in. And by him, I am referring to the six-foot-seven, four-hundred-pound man. And on top of this giant of a man's head was a little tiny cowboy hat, which was obviously made for a toddler. Still, the bells have not yet rung for my husband. For the rest of us faced with danger, we would probably be yelling for the check right now, but he was enjoying his peaceful meal. Remember, he had five teenagers, one wife, and one mother-in-law asleep in the camper, and this was perfect. It was perfect until the tiny hairs on the back of his neck began to stand up. He could feel her presence breathing on the back of his neck long before she ever spoke. In her deepest, raspiest, smoker's voice, she breathed these words into my husband's ear, "You gonna fix my car?"

Yep, that did it, but he didn't want to make any sudden moves because now, and just now, he began to see all the missing teeth, the toddler hat, and the fact that everyone in this place looked the same. Cue the banjo music. We were in Deliverance.

Of course, on his fast trot back to the camper, he saw it all now. The campers in this place didn't have tires, the cars were up on blocks, and everybody peeping out at him now was scary. Adding to the horror was the fact that the cowboy had taken a liking to my husband and was following him back to the campground. The hubby swung that camper door open and yelled, "Everybody up!"

Folks, getting all of us dressed in under fifteen minutes was a new state record. As the cowboy was easing closer and closer, my husband declared, "Honey, I may have to shoot this feller." It looked like he was herding chickens, but he got us all ready and back in the seatbelts on for our exit out of Deliverance. Let me tell you, he took that map and a big red marker and placed an *X* on this very spot with the initials NDR noted beside it. I asked what on earth does that mean. To which, he replied, "No dang reason for us to come back here."

One day, years later, we were sitting at a window seat at a brand-new Cracker Barrel enjoying breakfast, when one of the kids pointed out, "Hey, that over there looks familiar."

And it was. The hubby yelled to our waitress, "Check please!"

Keeping Them out of Jail

The distance between changing their diapers and handing them the car keys is never long enough.

All I can say is, you better prepare yourself for what seems like a never-ending nightmare that begins with, "Hey, Mom, can I drive?" I knew this day was coming, and since I prided myself on being the greatest-of-all-time kind of parent, I had devised a plan of action to tackle this nightmare. I convinced my son that driving the golf cart and lawn mower were actually the first steps in getting your driver's license. My plan appeared to be working as the yard stayed nicely trimmed, almost scalped at times, but trimmed nonetheless. And many a farm chore was completed on time in that golf cart.

I remember one time when the hayfield was ready to be cut and baled. But wait, before I go any further with this story, you may want to sit down. I am about to confess a sin, and I do not want to catch anyone off guard. There is something you city folk need to know about hay baling. Mississippi could be in the midst of a drought with no rain in sight for weeks, but just let us cut that hayfield and all a sudden a hurricane will start brewing overnight in the Gulf of Mexico. I kid you not.

When faced with hay bales on the ground and rain just over the hill, you find yourself thinking, *Hmm, I wonder if the kids want to learn to drive the truck today?* As the hubby was getting the flatbed trailer hitched to the back of the farm truck, I was standing in the children's den, cutting my eyes back and forth across the room, trying to decide which kid was going to get the driving lesson today.

"Hey, son, you wanna drive the truck?" There, I confessed it. Insert waiting on social services to arrive.

After a brief lesson in driving that old farm truck and a much-extended lesson on how we do not run over Mommy while she is slinging bales of hay onto the trailer, we headed out to the hayfield. It took all day, but we got those hay bales in the barn before the rain set in. Praise the Lord. Oh, so that my defense team has something to work with, I would like to add for the record that this only happened once, and we may have been drinking at the time.

When it came time to legally allow the son to drive, he did great. He passed that test on the first try. I was one proud mom. Let me stop now and say there is a big difference between passing that test and actually passing the local AA van full of patients headed to their Alcoholics Anonymous meeting. Insert our insurance company buying that van a brand-new side-door mirror.

While my son, Eli, was standing on the side of the road talking to the law and thinking just any minute he was going to end up in the back of that patrol car, the van full of patients was giving each other high fives and thumbs-ups because their afternoon meeting had been cancelled.

This, along with the exception of a school parking lot incident, he turned out to be a terrific driver. I would also like to stop here and add for the record, if you have a teenage son, you will end up paying more in insurance premiums than you actually paid for your house. I kid you not.

Now enter the daughter learning to drive. With her, the golf cart turned out to be very hazardous to the cows. "Mom, she just hit another cow!" My son would often inform us.

And then there was the incident with the four-wheeler, the telephone pole, and the FBI. Due to the statue of limitations, I will need to keep the details quiet for a few more years, just in case. "Mom, I don't want to go to jail!" Rebekah pleaded.

Before we got that girl grown, cows and telephone poles were the least of her worries. My airheaded bubble of a child got caught for speeding. Well, actually, she thought she got caught for driving too slow, but it turned out not to be the case after all, and she and I both ended up in court. I kid you not.

Let me take you back a few years to the alleged incident. It was Sunday night after church, and she was taking her boyfriend home after the service. It was a rule at our house that you called when you arrived at your destination and you called when you left there. If you did not follow those rules, you lost your driving privileges. So I get the call: "I'm leaving." And within three minutes, she called again, but between the panic in her voice and her sobbing, I could only understand every few words. "Cop, blue lights, help me, Jesus, I'm going to jail!"

Now as a parent on the other end of that phone call, I was left thinking what on earth could she have done in three minutes. Seriously. So I told her to put the phone down and wait for the officer to come tell her what she did wrong.

"What did I do? Was I going too slow?" she asked the officer.

"Ma'am, you were speeding. I need to see your license and registration."

"What? No, I wasn't," she said as she handed the officer her driver's license and her credit card through the tiny opening of the window.

"Ma'am, you are going to have to roll down your window, and I will not need your credit card."

"I want to go ahead and pay for it now." And she handed the credit card back to him.

He began to explain the process and walked back to his patrol car to check her license. Insert another frantic call to Mom. "Mom, I have to go to court!" Insert frantic sobbing. "I really wanted to go to college. Mom, I really did, and now I can't!"

Now I was thinking, *what on earth did she do?* I was beginning to panic just a little myself because I was not sure what she has done and wondered if I was going to have to get a lawyer. As it turned out, the ticket was just for speeding. And when I say speeding, I mean, something like driving 35 in a 30-mph zone. Yep, and this, dear readers, began our introduction to the court system.

Since this was her first offense, she was granted the opportunity to plead guilty in a court of law. Next, she could enroll in a defensive driving school and go onto college without any problems. "Sign me

up, Mom. I want to go to college," she said. I very well knew that a little speeding ticket was not going to prevent her from a college education, but this theory was working, and I had no intentions of correcting it.

Let me just say that the courtroom was not what I expected. Never having been thrown in front of a judge before, I really had no idea. The television set led me to believe there would be men in suits and ties, wooden pews, a gavel, a bailiff, and the court reporter. What TV failed to reveal was the screaming toddler sitting behind us, spewing orange Kool-Aid all over the back of your head, the smell of those who, for some reason, chose to refrain from bathing, and the smell of alcohol that reeked from the person sitting next to us who insisted he did not deserve his DUI.

Oh, and let's not forget to mention just how scary criminals can look when you're sitting up close and personal.

One by one, each case was presented before the judge. Apparently, my daughter was going to be the only one in court that day that was actually guilty of a crime. As we sat there listening to the criminals pleading their cases, my daughter was beginning to change her mind. "Are you sure that man is not going to put me in the jail today?" it was followed by, "I think I am going to throw up, Mom!"

I will say, when faced with going before a judge, your body will revolt and turn on you. I was just as nervous and nauseated as she was, and just minutes before the judge called my child's name, she had decided she could live without a college education, and she declared, "I change my mind. Let's just pay the ticket. I don't want to go to college anymore."

When her name was finally called, I'll have you know that my airheaded bubble raised her hand and shouted across that courtroom all the way over to the judge, "I'm guilty! Can we please leave now?" Folks, she may have been a half-grown young'un, but as my daughter was standing in front of that judge, all I could see was a little girl with a pink hair bow holding onto a Barbie doll. My husband arrived just in time to see that picture too.

After the traumatic event was all over, my husband and that patrol officer stood side by side reminiscing about days gone by and

talking about the fact they had gone to school together—a detail he knew all about but failed to share with us until our daughter had learned this life lesson.

She may very well have been the one learning a life lesson, but her momma was the one with the aching heart. Needless to say, she did learn it and went on to get one of those college educations.

Revival

This morning, as I was making a Facebook post in a nonchalant attempt to remind my grown kids to meet me at church, I was taken back to years ago in the days of Sunday chaos at the Baylis's household. Funny how some memories just pop into my head when I least expect them to. Rebekah was just an infant, no more than three months old, and Eli, well, he was fifteen months older. I remember it like it was yesterday.

While I was busy getting myself and the two babies ready for the first evening service of revival, my husband had not yet returned from fishing. Insert rolling eyes here. I can still hear my husband proclaiming, "I won't be gone long."

I laid out everyone's clothes and proceeded to give Eli his bath. I finally got that wiggle worm bathed and dressed and in front of the television. He was so handsome with his cotton-top head of hair. I am sitting here now with a smile recalling my words, "Okay, Eli, you be good while I get your sister ready."

I put that sweet baby girl into that baby tub, and before long, she smelled like pink baby lotion and was dressed all in ruffles. I glanced over to the clock and asked God to put a fire under a certain husband's hiney. Remember, folks, this was all before cell phones, and we only had one family vehicle—a truck.

As I placed that sweet little girl into her playpen, I could hear Eli giggling down the hall. I eased to the bathroom door to witness what I already knew had happened. My son was bathing, in the baby bathtub, fully dressed. Big sigh, as I had not yet learned how to use cuss words. That actually didn't happen until their teenage years. I think this is around the time I was getting the hang of the ever-so-popular momma-finger pointing.

I got him and his soaking clothes out of that plastic blue baby bathtub and pointed my finger down the hallway. It was all I could do not to laugh at that tiny naked hiney running toward his bedroom. Soon, outfit number two was all buttoned up and still no husband in sight.

"Eli, sit right here and be real good, okay?" I told my son. A quick check on the sweet little baby girl revealed the immediate need for another diaper. Why is it when you get them all dressed up, you have to stop and change a diaper? Seriously, it never failed.

The clock was slowly inching toward time to leave, and I was nowhere near ready. As a mother of two, you learn to get dressed faster than a NASCAR pit crew can change those tires. Only thing is, if you forget to drain the tub when you exit the bathroom, you will find yourself pointing a finger down the hallway again. I will have to say, as he was climbing out of that tub fully dressed, he was a happy little boy. Soon, outfit number three was all buttoned up and still no husband in sight.

This is where I realized there was no such thing as ESP. If there was, I know one husband who would have never returned home without police backup. I was busy gathering up the diaper bags, baby bottles, pacifiers, dolls, toys, and Bibles when I heard it. Imagine my horror as I plucked my eighteen-month-old out of our family toilet, fully dressed. Soon, outfit number four was all buttoned up and still no husband in sight.

When the wannabe Bill Dance finally arrived, he had less than five minutes to get dressed and to the church on time. I dared him to release one drop of water from any faucet in that house. He slipped into his clothes as I loaded up the seventy-five pounds of equipment that was needed when exiting any home with babies. As much as I was not happy about his being late, I was even more upset about having to drag the boat with us to church. Just once, I would like to arrive at church looking as though we intended on showing up there. If you have ever sat in a pew with a hot roller stuck in the back of your hair, wearing your ugly house slippers or realizing you only put mascara on one eye, you know what I mean.

As soon as we cut into that parking lot on two wheels, I noticed right off that everyone was getting out of their cars with casseroles or desserts, and as a Southern woman, I realized I have failed once again. How did I not remember to make a casserole? We make our way into the fellowship hall and soon found ourselves surrounded by women saying, "Those babies are so cute." I loved my church family. They always loved my children and were so happy to see them every time we walked through those doors.

It is somewhere about this time I heard my husband say, "Yes, it is a handful to get them all dressed up and here on time." I am not going to tell you what I was thinking.

As I made it through the crowd, I stopped to speak to my pastor's wife, and her words still haunt me a little to this day. "Dear, we do not have a nursery tonight." How could you not have a nursery during revival? Now don't get me wrong because I loved all that preaching and singing, but after being stuck in that house all day with all things babies, I needed this hour. And besides, the husband was really praying the sermon was on how menfolk needed time alone to fish because he knew his real sermon was still waiting on him when we got back home.

I am not really sure what happened next, as my pastor's wife revealed, "Revival starts next weekend, dear. This is deacon's supper." Yep, that's right, deacon's supper. And we were not supposed to be there. I vowed right then and there to never go back, but I did.

To all the young parents out there, I want to say, hang on. It is so important. The rewards come later. Trust me.

Eighteen years after I plucked that toddler out of my toilet bowl, I heard these words from my son: "Hey, Mom, I just preached my first sermon. I had eighty people in my congregation." Eli was on a mission trip walking across Africa. I laughed out loud when my grown son told me he had not bathed in three weeks.

Mothers

Mothers—we all got them, and I am sure we all have tales to write regarding them. Let me tell you about mine. First off, she was born in a log cabin. I kid you not. She was raised up with five brothers and could hold her own on their farm. She stands all of about five foot three and one-half inches tall. Still to this day, my siblings and I have no doubt she would break out that switch if she needed to. My brother and I know all about that switch. To my baby sister, it is nothing but hearsay, but that is another story.

Growing up in the trailer park on a really tight budget, my mother could make a meal for us out of flour and water, and there were many days she needed to. God always provides for His children, but that doesn't mean He will have it wrapped up nicely in a pretty box in the freezer section of the supermarket. Sometimes, it means you have to get up at dawn and work in the fields to get it. And that is just what we had to do. When most of the schoolchildren were counting down the days to summer fun, my family was counting down the days to the summer garden. Looking back on it now, it was a blessing, but to us as kids, it was not.

Mother would load us up at sunrise in her Volkswagen Beetle and head us to the fields. She never complained. Of course, my brother and I were singing "Swing Low, Sweet Chariot" and wondering if we could report this to the welfare people and not get a whooping if we did. Whether it be peas, butter beans, or corn, we loaded that Volkswagen all the way up to the roof. There were days I just knew my brother and I would have to ride back home on the hood. I didn't know just how important that really was until I had kids of my own and providing meals for them too. And all that garden stuff I

fussed about learning was a blessing in disguise that she was handing down from her generation to mine. You can ask my kids. I handed it on down to them too. In this uncertain economy, that type of learning needs to be handed down.

As we grew into adults and the world became more advanced with modern means, we tried to bring Mother into this world of technology. The microwave she learned, but the computer, not so much. To my mother, there were only three websites on the entire World Wide Web: The Weather Channel, Paula Dean, and American Idol. There were many, many discussions regarding the satellite dish and how she couldn't ever disconnect the wires again. And then there was the day she was adding on the calculator and she couldn't figure out how many ears of corn she could get for a hundred dollars.

"Mother, that is the remote control for the TV, and it will never tell you that answer."

Oh, and let's not forget the advancements in cars. "No, Mother, just because something lights up on the dashboard does not mean you have to pull the car over and wait for someone to come get you." My husband said he was going to disconnect those dashboard lights if she didn't stop. Of course, he was just joking.

My mother is a joy to have around, and she can still work circles around the rest of us. In fact, I think the grandkids have made her stay so young. If someone mentions a trip, she will load up and go. She goes all over this country with my sister and her crew. She even went with us to Key West. We loaded up the camper and a passel of young'uns and headed down to Florida.

One night, while everyone was sound asleep, I hunted for the smoke detector that apparently needed a new battery. All night long, I hear, "Beep. Beep. Beep." The next morning, as I am searching around the camper, Mother asked me, "Are you looking for the little round thing? Oh, I didn't know what that thing was and put it in the drawer."

We finally made it down and set up camp. Then we rented one of those golf carts and went all over that tiny island. She even talked me into going into the butterfly museum. I will be the first to tell you I may have had a few nightmares about that when it got dark.

Something about being in the room with five million butterflies will do that to you. She, on the other hand, loved it.

Mother touched just about every inch of that island. This brings me to the reason I brought this whole thing up. We had tickets to the glass bottom boat tour that takes you out into the ocean and gives you a view of things in the sea. Now keep in mind, my mother carries around a little medical bag full of all the things she may need in the event something goes wrong. Let's just say, this little bag is very, very important. Mother got so caught up in sightseeing, she lost her little bag. As we are standing in line to get on the boat, she says, "Vicki, have you seen my little bag?"

Folks, I thought my heart skipped a few beats. We could not get on that boat without that little bag. In fact, I don't even want to be on that island without Mother's little black bag.

"Mom, where did you last have it?"

She thought and thought hard then declared, "Well, I just don't really know, Vicki."

The hubby and I backtracked to all the places we had toured earlier, only now we were doing it at the speed of sound. And let me tell you this, I can still do a six-minute mile if I have to.

I found that little black bag with minutes to spare and we high-tailed back to that boat where Mother was waiting.

"Where have y'all been?" She then added, "We need to hurry. I don't want to miss this boat."

The first thirty minutes of that boat ride, my husband was bent over with his elbows placed on his knees, trying his best to get some color back into his body. I, on the other hand, was lying down on the floor asking Jesus to just take me home. Needless to say, Mother was not in charge of the little black bag the rest of the trip. She didn't mind. She was having the time of her life, and it was all worth it.

Raising Southern Boys

I believe it is safe to say I am not a true outdoorsy type of gal. As a Southern woman, I did my duty to the fullest extent when it came to raising my son up to be "Southern raised." I was there in that canoe on his first fishing trip. Granted, I was pregnant with child number two and wearing a very ugly life jacket, but I was there. He was no more than eight months old and sitting pretty in my lap as I made many a cast with that little Snoopy pole. And when that child jumped into that nasty pond water, I went in after him. Soon, my little man was able to cast his own pole, and I can still see him stripped down to his training pants just reeling and reeling until he finally got the big one—a half-pound bream. Yes, sir, that monster of a fish is still mounted on a wall in our house.

Soon, he was hunting deer with his daddy. I was not allowed to take part in this event. I have only hunted once in my life and seriously thought I would find myself missing and on the side of a milk carton before the trip was over. When I agreed to go sit in the woods with my husband, I had a different vision of how the day would unfold. I had no idea stuff like breathing could interfere with catching a deer. And heaven forbid, you want to have a little conversation. It's not like the deer can understand what I am saying. And let's just say, apparently, I cannot eat a tater chip quiet enough to please anyone. To all you newlywed girls out there, hunting is not really like a date, so there is no need to fix your hair. Needless to say, I never got asked to go hunting again.

When hunting turned to baseball and football, I was there. I was also there when he and two of his little friends learned how to make a sparkler bomb. If you ever hear, "Ten, nine, eight, seven, six,

five—wait. Eli, there's your mom," you need to panic. Now don't you all worry, that phase of firecrackers didn't last long and only resulted in just two sparkler bombs that I am aware of. When you find yourself asking God to not let your child be the one that burns down the neighborhood with firecrackers, you know you are raising a boy. I might add that this phase must be inherited. My husband was successful at catching the entire marsh on fire with bottle rockets when he was a little boy. Oh, and just for the record, Eli's two little partners in crime grew up to be real firemen, so all turned out just fine. Eli, on the other hand, had a couple more lessons on fire safety before I got him raised. Parents, you really need to give specific instructions when it comes to teenage boys. Take for instance, if you ask your teenager to take down what is left of the pier after Hurricane Katrina, be sure to add, "And not with diesel and matches."

There were many a bug and frogs too. I recall the day Eli came down the stairs and confessed he had lost the turtle. Imagine my surprise because I had no idea we even had one. I can just hear PETA now if we hadn't found that snapping turtle and released him back into the wild where my son found him. Then there was the extended sermon on tarantulas when I stumbled across one living upstairs. From the safety of my yard, I yelled, "Son, you get that thing out of my house right this minute or I am calling 911!" Let's just say there was no more pet sitting at our house ever.

Oh, and one more thing, if you send your child off to college, be sure to take the bow and arrows out of the back seat of his pickup truck. Apparently, riding around on campus with those things is kind of a big deal. It results in getting a very scary phone call from the local authorities, and they don't really care what season it is. When that lawman got through with me, this Baptist needed a drink of something a lot stronger than grape juice.

Bat Fishing

In a normal world, my evening would have been perfect. A slight breeze was blowing off the lake, the sun was setting in the distance, and I was gently swaying back and forth on my porch swing, just enjoying a glass of iced tea and watching the husband cast his fishing pole off the edge of the yard. It was a perfect southern evening, no doubt. That was until he got his lure caught in a dried-out lily pad. I was listening to the play-by-play as he was fussing, cussing, and reeling. What happened next is, well, let's just say, another trip to the emergency room.

"Honey, a bat just bit me," he announced, interrupting my quiet Southern evening.

I looked up at the heavens. "Oh, good stars! Seriously, a bat, Lord?"

It turned out not to be a brown lily pad after all, but in fact, his lure had latched on to a flying bat. Now I don't know where I got this information, but I remembered you should not kill it, and we put that flapping thing in an empty Cool Whip bowl sealed with duct tape. This was followed by a brief discussion about who was going to drive the car and who was going to hold the bowl. I had the pedal to the medal, all the while listening to one very angry bat who wanted out of a bowl and a husband who had twenty questions about what was the doctor going to do. Now keep in mind that even though I had been to nursing school, they only covered the highlights.

"Keep that bowl on your side or I am pushing you out of this car. And I don't remember anything about bats in school!" I couldn't get to the emergency room fast enough.

Surprisingly, bats are not really welcomed in emergency rooms. I finally had to tell the husband, "Stop telling people!"

To prevent mass chaos from occurring in the crowded waiting room, the staff quickly moved us and the Cool Whip bowl of bat to a hallway in the back. One by one, the medical staff would stop by and ask us, "You the folks with the bat?"

People, this was a level two trauma center, and apparently, we were the first ever bat emergency. Trust me, they wanted nothing more than to get us rushed through and out the door of their hospital, but quite frankly, they had to do some research. In the meantime, the husband, the bat, and I sat patiently on a stretcher in the hallway, just waiting. A short time later, the local dogcatcher came and got the bowl full of bat. What happened next, I wouldn't wish on my worst enemy. Our nurse, who had just returned from a tour of duty overseas, brought in five syringes full of rabies prevention medicine. Folks, you could have put a kitchen match inside the hole of one of those needles. It took all his strength to get that thick medicine out of those syringes. I will say the husband handled it well. I, on the other hand, had to lie down on the stretcher until the dizziness had passed. Yep, bat fishing. All you need is a pole, a bat, and good insurance.

Ice Cream Truck

You know the saying that God watches out for idiots? Well, okay, I may have made that saying up, but it's true nonetheless. If you have any doubts, follow me around for a couple of days. Take the time my daughter had to have an ice cream truck. Yep, she was going to make millions. Not really. It was just for a high school senior project. Anyway, we got on the Internet and found one. The pictures looked awesome and just what she wanted. We packed the emergency bag of clothes because Momma always said to, gathered up the money, which I need to add took divine intervention, and then headed out West.

Now I've said it before, and I'll say it again: my family has a knack for always getting lost, and it is usually in the high-crime areas. I kid you not. I think it was about the fourth or fifth time we circled the neighborhood that I started to notice we were making the locals nervous. I could almost tell what they were saying with each passing. "Those folks are making me nervous. What do you think they are up to? I don't know but you see the crazy-looking woman in the front seat?"

Anyway, we all know what happens when I get nervous, and into the convenience store, we must go as a group, for safety, of course. As always, the women's restroom was occupied, and the daughter and I waited and waited and waited while the men folk finished up and headed back to the car. It turned out this establishment locked the women's bathroom door. Go figure. Information we could have used as we were walking by the clerk, but no.

It didn't take long before some of the locals wanted to become real friendly with the husband. Insert gun into story. Yep, it turned out

that when you put a gun on the dashboard, folks scatter. Meanwhile, back inside the lovely public restroom, the daughter and I were busy trying not to touch anything. Now this is the part of the story that I did not hear about until the next day. Thank you, Jesus. This store was the target of a robbery in progress. Yep, that's right. The husband noticed two fellers about to carry out their plans. One was the lookout, and the other had just made three passes in front of the glass doors. On his last pass, he threw the hood over his head, grabbed the door handle, and was about to walk inside. By the grace of God, the hooded man made a one last glance over to the Mississippi redneck with a gun sitting in my car.

By the time the daughter and I finished up, the clerk had already locked the doors and was smoking a cigarette. With shaky hands, she let me and my big ol' purse full of cash outside. Do I need to remind you, enough cash to buy an ice cream truck? See, I told you, God is watching over me.

We finally made it to our destination, and I wish you could have seen the look on our faces. Those pictures that we saw must have been taken some twenty or so years prior. Being from the South, we were raised to be nice no matter what. So we walked around the truck, kicking the tires, and making small talk about the weather all the while the seller talked about how wonderful this thing was. The daughter and I bravely entered this contraption, pretending not to notice the horrific odor coming from inside this thing, wondering where the body was hid and carefully placing each footstep for fear of falling through the floor. We dodged spiderwebs and dangling wires and even smiled when the seller decided to sweeten the pot a little by throwing in the moldy bottles of flavorings for free. I still, to this day, have no idea why I said what I said. I think I had just run out of nice things to say and lacked the ability to stop talking. Out of my mouth came these words: "Rebekah, would you like to sit in the driver's seat?" People, let me tell you if looks could kill, I would have burst into flames right there on the spot.

Once we got back in the car and all showered down with the tiny bottle of hand sanitizer I keep in my purse, she stopped crying. I don't think our car stopped until we hit Louisiana. Somewhere

between the tears and the shower, the decision was made to go look at the other slightly more expensive ice cream truck in Florida. Insert rolling eyes at the husband.

Our adventures were always learning experiences, to say the least. I bet you didn't know you can't cash a check out of state if your driver's license is expired. And it only makes matters worse if you try explaining why you need to get two thousand dollars out of the bank. Apparently, not many folks drain their checking accounts to buy an ice cream truck for school projects. Shoot, I might as well have been saying I was gonna go downtown and buy some drugs. I would have gotten the same look from Miss Uppity Bank Teller. And if you plan on traveling on the New Year's weekend, make sure your inspection sticker is good. The expired ones seem to be like flashing neon signs as you are passing back through the great state of Mississippi.

Anyway, back to the story at hand. Florida was where I decided to divorce the husband. Yep, he took another one of his famous back-road shortcuts. It wouldn't have been so bad had it not been for all the road construction and detour signs and midnight. There are only so many times you can pass the same store and not realize that some-one has been messing with the signs. Three hours and thirty minutes later, we made it back to the interstate. Do I need to mention it was about ten miles from where we jumped off it in the first place?

Right before reaching Tampa, we gave up for the night and found a hotel. To the clerk, I asked, "How long will it take to get to Tampa?"

To which she replied, "About three hours."

Excuse me? We are thirty-four miles away. What are we gonna have to do? Get out and walk the vehicle into town? But it turned out she was right.

We finally made it there and guess what? They are not home. Although I should have, I didn't see that coming. So we waited and waited right there in the CVS parking lot. After about three or so hours, we were tired, grumpy, and hungry. I think the CVS employ-ees were waiting for us to get out of the car with one of those Will Work for Gas signs before they actually called the police.

To make a long story short, the seller's son forgot he was supposed to be waiting for us, and getting directions from him was, well, like getting them from a three-year-old. The good news is the daughter loved the ice cream truck and all would have been perfect except for one tiny little thing— the key to this thing was in Orlando.

Let's just say it was a long ride back to Mississippi and leave it at that. It would be weeks before we found the perfect one, and may I add, it was about thirty minutes down the road from this one.

Football Game

High school football season around here was a big thing. Seriously, we even had season ticket sales, chair back seats, parking passes, and tailgating. And not just a few cars parked around having chips before the game, but motor homes, campers, tents, big grills, and tons of folding chairs. Oh yeah, we got this done right. Now granted, before we moved the kids to this school, my son, Eli, had no interest in football, but when he found out there was a weight-lifting class that was only offered to football players, he said, "Sign me up."

And he started football. So naturally, we had to get season tickets, chair back seating, and parking passes. Each home game, a family member would wheel their big motor home into our assigned parking spaces, and we would set up tailgating. Oh, the fun we had! This continued on even after the son graduated and went on to college because the daughter still had two more years left in high school. On one occasion late in the fourth quarter, our team had a pretty big lead, and we decided to beat the traffic out.

Somehow, as the daughter was climbing over the back of her expensive chair back seat, she got her entire leg stuck when the chair folded up. We just can't be normal ever. Everything was okay, only just a little embarrassed until she realized there was blood everywhere. You know how the tips of your fingers have prints? Well, your toes are the same way. Only now, she was missing a big toe print. My husband took off to get the car pulled up to the gate, and I was helping drag her along when she announced, "Mom," followed by silence.

Yep, she fainted, right there, in the middle of everyone. Some men helped me lay her down on the concrete floor, and the next thing I knew, the fire department was taking control of the situation.

The daughter was in good hands with two medics at her side and one tending to the massive blood loss to the foot. The husband was having trouble getting to the gate because the ambulance was in the way—yep, the ambulance. I kid you not.

Minutes into their assessment, my daughter woke up confused as one of the men said, "It's the fire department, honey. Just lay still."

To which she replied, "Well, am I on fire?"

At this point, I was seriously considering easing back into the crowd. They seemed to have things under control, and besides, I was not real sure exactly what our insurance company was going to cover at this point. A few minutes later, she realized, "Mom, am I on the ground?"

The medics were continuing with all sorts of medical questions, and all this child was worried about was, "Is my panties showing?" Of course, by this time, the crowd was now watching the 911 event unfold, and friends and family had started forming prayer circles and shouting encouraging words like, "Hang in there, girl." And we could hear her name being tossed about throughout the crowd. "It's Rebekah! It's Rebekah!"

After this traumatic event and we got her back to the car, she said, "You do know I have to change schools now, right?"

Yep, you can dress us up, but you still shouldn't take us to town.

The Scam

I am a firm believer that you must teach your kids how to grow into adults. First, you live by example, and then you help them grow with what they have learned. Take for instance when my little darling needed to get an inspection sticker for her car. After she got in college, I thought it was best to let her be responsible for getting stickers, tags, and oil changes. That is the least she could do being I got her through division, telling time, the continents, tipping, taxes, and tithing. All which gave me and her dad gray hair.

"Mom, I will never need to know anything about continents." It was followed by division. "I am not learning that, and you can't make me," said my stubborn child. And I am still having nightmares about clocks. "Mom, it clearly reads one hour and fifty cents," declared the honor student as I seriously considered learning how to smoke cigarettes.

Anyway, the hubby and I were out of town when the daughter realized she needed an inspection sticker. Now I will take a little responsibility for telling her she will go to jail if that thing expires. Folks, I had to. If not, we would be paying the great state of Mississippi a yearly fee for the expired ones. So she set out to get her five-dollar inspection sticker, and soon, she learned she must have a new windshield in order to get that sticker. Insert her lesson on deductibles.

"Do you have insurance?" asked the windshield repairman.

"Yes. Why?" the daughter replied.

"It's to pay for your new windshield."

The windshield repairman called our insurance agent. Our agent then asked to speak to my daughter.

"This phone conversation is being recorded," informed the insurance agent.

"Huh?" the daughter said.

"You have a thousand dollar deductible," explained our agent.

"What does that mean?" said my child.

"You will need to pay a thousand dollars before we can pay for your new windshield."

"What?" the daughter asked.

"You have to pay the first thousand dollars of any claim before we pay the rest."

"Wait a minute. I got to pay you a thousand dollars?"

"When you file a claim, you pay a thousand dollars, and we pay everything after that," continued our agent, trying her best to explain.

"Well, that doesn't make any sense," the daughter replied.

Insert a brief sermon on deductibles. I can just see the bubbles floating all around my airheaded child as she is trying to grasp this new concept.

"And that is what a deductible is," the insurance agent concluded.

"Let me get this straight. I pay you a thousand dollars, and you pay this windshield company a hundred and forty?" the daughter clarified.

I can only imagine the emergency meeting being called after this phone call and that agent trying to find the loophole that can get my little airheaded child off my policy.

"Oh my gosh! Mom, I have to pay them a thousand dollars today so I can get my five-dollar inspection sticker. I'm not falling for this scam. I'll just pay for the windshield myself, which is cheaper. Who needs insurance? And, Mom, I am doing all this grown-up stuff, and you and Dad are out camping. I think that is against the law, isn't it?"

When Company Comes Calling at Midnight

There are two things you should know about being a mother of teen-agers. First, your house is always going to be full of kids. Second, your refrigerator will always be empty by morning, especially if there are boys involved. No matter how hard my daughter tried to hide her leftovers in the fridge, somebody would find it by morning. "Mom! Make Eli's friends stop eating my food." I never knew who would be sitting at my breakfast table. Once those kids entered our house, they were treated like our own. "Mind your manners, pick up after yourself, church starts at eleven, and don't burn down my house."

Not sure if you have ever noticed, but down south, women can be "Miss Prim and Proper" all day long, but the second you mess with our kids, we will put you in a box and bury you in the woods without being late with supper. Case in point—the day we all loaded up and headed back down to the Keys for spring break.

Since the kids were half grown and I was a firm believer in let-ting my kids learn while I watched, I let my son drive his truck all the way there. I knew he would be doing it soon enough, and I might as well show him the way. If memory serves me correctly, this trip down, we had five teenagers and my mother.

Somewhere at the start of Florida, we came upon some idiots in a vehicle, a blue truck to be exact, and they were trying to run my son off the interstate. Said vehicle would ride the bumper for a few minutes then pass and stop right in front of my son. Once, they even hauled tail up the highway and stopped. Then they got out of their vehicle and grabbed something out of the cooler before jump-

ing back in the truck and starting the shenanigans all over again. I believe it is safe to say, alcohol was involved in this scenario. Insert a call to the Florida Highway Patrol. I need to stop here and offer my apologies to all the blue trucks traveling in Florida on that particular day, because for the next two hours, every blue truck on Interstate 75 was pulled over and questioned. Apparently, Florida doesn't play when it comes to keeping their roads safe. Of course, it may have had something to do with my telling the officer, "I'm fixing to shoot the tires off that vehicle if you don't get here fast enough."

Anyway, back to my reason for this story. Let me tell you about the time my dog caught a burglar in the backyard. It was about 12:30 at night, and I was awakened by the barking dog. Insert me waking the husband and turning on all the spotlights. Might as well have a clear shot, right? So as I am peeping out the back door window, I see the criminals, with their flashlights, hiding behind the trees. And my dog has one of them cornered. Insert call to 911.

"Y'all better get here fast. My husband is getting the keys to the gun cabinet as we speak," I informed the operator.

About this time, my dog drops down to the ground. The criminals have killed my dog—not my dog! Insert my telling the 911 operator, "He just killed my dog! He's armed! Y'all be careful."

It didn't take long before the cops showed up and had arrested said criminals as they were fleeing my driveway. Dispatch called me back and asked if my husband would step outside for a minute. As he approached the two officers, both of whom stood no less than six foot five, he noticed one of the two suspects standing at the front of the patrol car. The other had been placed in the back seat. This five-foot-six male suspect had his arms positioned at the back of his head and was extremely nervous acting. "Mr. Chris! Mr. Chris, it's me," pleaded the criminal. The look on that boy's face when my husband informed the officers, "I've never seen that boy before in my life," is what Master Card calls priceless.

You know the saying, there are always two sides to every story? This is proof. Now let me tell you the story from the criminal's side of view. My son, who was upstairs asleep at the time of this alleged burglary, had extended an invitation to his friends for a few hours of

night fishing on the small lake behind our house. Only problem with this fishing event was my son had fallen asleep. The flashlights I happened to see in my backyard were cell phones as the criminals were making frantic attempts to wake my sleeping child. The "criminals" were hiding behind trees because they knew my husband had guns in the house and they did not want to be shot. I will say I believe those young'uns were having a small revival in my backyard 'cause they thought they were fixing to meet Jesus. And that dog that fell out on the ground just wanted his belly rubbed.

So there you have it, folks. Things may not always be what they seem. But I know one thing for sure, if those two teenagers ever had any thoughts of being a criminal, those ideas vanished that night. In fact, one of those "criminals" now has the title MD written behind his name. And the other one—the girl—went on to be Junior Miss and president of the student body at a major college.

Of course, my kids asked me to stop calling 911 on their friends. Let's just say, night fishing events were fully advertised from that point on.

Florence and the Tube

Let me start by saying I know me and I knew I was going to have trouble doing this, but I did it anyway because I am stupid!

Here is how it all went down.

Lady called me from the calmness of the waiting room where I have been practicing "breathe in, breathe out, breathe in, and breathe out." She was so nice. Why, I almost fell out on the floor after I heard her say, "I'll need $196." Look, I would love nothing better than to give this clinic $196, but let's face it, I am not rich. Nowhere near it. I went back to the waiting room to wait for the husband to bring the checkbook from the car. Oh, that reminded me that I needed to add that check to the top of the prayer list, and if that sweet little lady was a praying woman, she needed to be praying too. Anyway, before the husband came back to the waiting room with the checkbook, here came my Florence Nightingale. Let me tell you she was really awesome. So calmly, she asked all sorts of questions and waited patiently for me to answer each one. Now remember, I am a tad bit shy of full panic lockdown, so it takes me a little while to recall stuff like my name and facts like, "Do you have any tattoos or body piercings?"

She explained everything, and somehow, I was getting calm. This woman had put me in some kind of a trance. We walked around this corner and that corner and this corner again. I changed clothes into something with no zippers or latches because I have read that MRI brochure no less than fifteen times. I then followed Ms. Nightingale into the room. It was here I was met by another lady who was in charge of the tube, and she reassured me I can do this. She went over all the things I needed to know. I climbed onto the

table. I was calm. Shoot yes, I can do this. I got my little ear things in my ears and my nurse call button in my hand, and in the tube I went.

Fifteen minutes passed, and a reassuring voice came over the speaker. How I am doing? I am doing this. Insert loud scary noises. But it was no problem because I am awesome. I got this! In walked the keeper of the tube, and she readjusted something on my leg. Not really sure what 'cause I was trying not to know all that was going on because, well, if you know me, the less I know, the better for everyone involved.

Soon, another fifteen minutes passed, and I was still doing great. Loud scary noises continued. Not wanting to brag, but I could probably tackle bad guys in the dark because I was that confident. But then, I noticed in one hand was that nurse call button, and on the other hand was—OMG! I forgot to take my ring off! Panic! Panic! Panic!

Frantically, I went over that brochure in my head. Remove all your jewelry! Remove all your jewelry! Now I was scared. What did that mean? I was trying very hard to get a handle on this new sense of fear, because if I couldn't, I tell you, it would not be a pretty sight. And of course, I did not want to get Ms. Nightingale in trouble, but clearly, I was beginning to doubt the entire nursing profession at this time as well as the receptionist, the cashier, and the man who opened the front door when I walked inside that there clinic. Seriously, how did they let me in there with my jewelry still on?

"Hello, Florence?" I called out.

No answer. But then again, this thing was loud. And you know, I had been in this tube for quite some time now, and my hand was still attached to my body. Yes, that was the fear going through my head. Was this giant magnet going to grab on to my ring and make me stuck to this tube? Yes, I admit that is what was going through my head. I didn't want to get anyone in trouble, but I was really fond of my hand, and I wanted to leave here with everything I brought to this party.

"Hello?" Still no answer.

"Flo? Where you at, Flo? I got a question!" My voice was getting a little shaky. It was at that time I was thinking everyone had gone home.

"Flo? Security? Housekeeping? Anybody?" I continued.

Still, I was trying to remain calm and to not move in this contraption because I didn't want my hand stuck in this tube. I could just see the headlines—Woman Breaks Multimillion-Dollar Machine. And I got news for that there clinic. If I had to replace this thing, I would be making monthly payments at twenty-five dollars a month until I had that baby paid.

Another few minutes passed. No one was there. In my frantic mind, Jesus had come back, and no one was left in this place. Just me, the magnet, and my ring!

Shortly, I was in full panic mode, so what did I do next? I pressed the emergency button. Immediately, I heard *whoop, whoop, whoop!* Yep, I did it. There was no going back now. And just for the record, the only thing louder than this contraption I was stuck down inside was that panic alarm. Well, that and the sound of staff running to see what had happened. In came the keeper of the tube. She was so nice. Not once did she make me feel bad for pressing that button. She calmed me down again.

She then showed me where my clothes were and told me to take a seat. She let me know that my ring was okay, and it wouldn't have hurt one bit. Well, dang. Insert rolling eyes.

It was here that I began to be embarrassed for my actions. Why did I give these people my real name? And it was a long walk of shame back to the waiting room. The keeper of the tube said, "Next time, get the doctor to give you a little something." Well, it was obvious she doesn't know me at all. That there clinic didn't have enough staff to get me back in that tube.

Eating with High Society

I finally got myself invited to one of those high-society functions. My sister and I were members of the same organization, and one of its members was having a big reception at their mansion. Now my sister was always rubbing elbows with the rich and famous. It seemed every time the governor came to town, she got to have supper with him. Now I don't know about you, but I didn't have high-society clothes just lying around in my closet, so off to the mall I went. It took all of twenty minutes for my sister to find the perfect outfit. Of course, I thought I was going to have to help close up the mall before I found one, but I did.

We arrived at the mansion to find the place was surrounded by water on three sides, a boathouse, waterfalls, and even its own beach. I kid you not. As we pulled up, the parking lot attendants—yeah, you read that right, the parking lot attendants—motioned for us to follow their directions, which we did because we were all dressed up and on our best behavior. We may have been raised up in the trailer park, but Momma taught us how to behave. Anyway, it was here that I began to see the golf carts. Yep, we got picked up and dropped off at the front door. I kid you not. Only one small problem: this fancy golf cart was a two-seater, and I, being the oldest, was going first. But before that thing got going, let me tell you what Toot did. She jumped in my lap. I am almost certain that proper etiquette states, "One should not arrive at the front door with a thirty-seven-year-old sister sitting in your lap."

Once inside, we signed our names with that fancy feathered ink pen and were greeted by a line of folks, just shaking our hands as we walked passed. Kind of like what you see on TV with the Queen of

England. It is here I should note if you find yourself standing in a grand foyer with matching staircases on both sides and a view that overlooks the lake, be very careful of the marble floors. If you are not paying close enough attention, you might not notice the foyer drops down about ten inches once you enter the living room. I actually think a bright piece of orange floor tape might be necessary there.

The backyard was dotted with tables dressed in white linens, flowers, and candle flames blowing with the quiet breeze from the lake. And a large white tent covered a long buffet line. Now I am not talking chips and dips but stuff like seafood this and seafood that. Each dish was labeled with fancy note cards telling you what is what, and there was even a flowing fountain of punch and glass coffee cups and plates. I was one nervous woman and not about to go through that line first. In hindsight, this was where I made mistake number two. I got behind Dolly, the could-have-been-a-model, and whatever Dolly did, I did. Since I figured my half-flight ordeal in the living room was enough to get me tossed out of this shindig, I was not about to make any more mistakes. So when Dolly picked up one of those long green asparagus sticks wrapped in a cute little flour shell, I did too. And when she dipped that thing in the silver bowl of white sauce, I did too. As I was making my way through that fancy line, I began to wonder. Just how do you eat one of these things? As it turned out, they sure were pretty, but they be nasty. And I am sure an acquired taste, but face it, folks, I was raised in the trailer park, not much fancy asparagus there. I should have left that thing on the buffet, but since I had it sitting on my fancy glass plate, I might as well eat it. Toot walked by as she was heading to the buffet, and I whispered, "Make sure you get some of that asparagus."

Yeah, I know, I shouldn't have, but I did.

Whisper in a Sawmill

Mother forgot how to whisper. Case in point—when she is in church. On special occasions like Easter and Mother's Day, we would surprise my mother by just showing up at her church. One by one, Mother would introduce us to her church family as they would make their way over to her pew. Now do not get me wrong, because in my mother's eyes, she was not gossiping. We all know that is a sin. And before anyone cast any stones at us, she only repeated what was already on the church bulletin. I can hear it now. "This is my daughter and her husband." From everyone's response, I knew we had been the topic of many pew conversations as mother would describe me to her friends.

"No, this is the oldest one. It is Terri that runs the marathons, not this one." Mother would usually reach over and pat my leg. "This one enjoys the sweets a little too much."

This is usually followed by, "No, ma'am, it is Terri that has blessed me with the five beautiful grandchildren."

After about three or so church members saying, "We've been praying for you, dear," you get the sense that your mother has been telling all your secrets. I'm actually surprised I didn't have someone ask me about my weight.

Each introduction to a member of the congregation was usually followed by my mother describing their health issues as they were walking away: "He has been having a little trouble with his gout." or, "Her sugar is acting up lately."

Please keep in mind that my mother learned to whisper in a sawmill and she was not only telling me but she was telling everyone in a four-pew radius.

"They can still hear you, Mother." I kept telling her.

I tell you all that to tell you this. Mother had been dealing with potholes on her road for years, and she'd had enough. Insert my mother getting into politics. She was determined to get her road fixed, and she found the perfect candidate to do that. Soon, she had not only signed herself up for knocking on doors, but she had signed me up too. One by one, she and I made our way through the county passing out pamphlets. I believe it was during the first week I realized this may be a costly adventure for me. Since we live in the Pine Belt, I needed a little help getting turned around in some of those driveways.

"Mother, is it clear on your side?" I asked.

According to my copilot, it was. Yep, it was clear all right, all the way up until the tree abruptly stopped my car. Insert massive bumper damage and a trip to the body shop. We braved big dogs, chickens, bad weather, and more than a few very scary people, not to mention relatives of the opposition.

Apparently, "politicking" brings out a side of my mother that I did not know existed. With each house, I was privy to, "Boy, they sure do need to fix this."

All this critiquing was going unnoticed to the unsuspecting homeowners until, "This place looks real nice from the road, but my goodness, they need to clean this porch off and maybe do a little painting. Vicki, just look at all these spiderwebs! I have never seen such a mess." Mother was giving me the play-by-play of her discovery.

Needless to say, I could not look at the spiderwebs because I was busy looking eye to eye at the homeowner through her dirty screen door. And the homeowner was busy listening to my mother whispering in a sawmill. Not wanting to lose a vote for our candidate, I had no other choice but to say what I did: "Ma'am, we are looking for my cat. Have you seen her?"

And with that, I begin to describe my imaginary cat. Thankfully, this homeowner had not seen that imaginary cat because I really did not want to take a cat home with me. I then grabbed my mother's arm and made a mad dash back to the car.

It did not take me long to change our politicking game plan. I found it was less embarrassing to alternate the houses. Besides, how

much longer was my luck going to hold out before I had to actually end up taking home a cat? We covered a lot of ground and had the best time. Soon, my mother had critiqued every house, barn, yard, chicken pen, and flower bed in the county.

I will never forget the day I realized she needed to retire from politics. It had been raining off and on all day, and I pulled the vehicle up to the homeowner's garage. It was her turn to knock on the door, and I waited in the car. Insert my mother pressing the garage door button instead of their doorbell. As the garage door begins to close, I hear my mother yell, "Vicki!" And with every inch that garage door traveled closer to the ground, my mother stooped over a little more and would yell my name again, "Vicki!"

People, you have not lived until you have to get out of your car, go around to the front door of a house owned by someone you have never met before, and say, "Excuse me, my mother is trapped in your garage. If you will let her out, I promise you will never see us again."

I am so thankful they did not call the law. And after my mother gave them a thorough chewing out about their doorbell not being a doorbell after all, I put my redheaded mother in my car and got the heck out of Dodge. I knew this would be our last door when my mother said, "Oh, shoot, I forgot to ask them about your cat."

The Funeral

There are many ways to know she is my daughter, but if there was any doubt, here is all the proof you will ever need. Rebekah, my should-have-been-a-blonde child, decides to go to Target because she is a college student living on campus, and I'm sure that dollar is burning a hole in her pocket. Picture this, if you will. She is traveling in her little car, ponytail, big sunglasses, windows down, music blaring, and singing at the top of her lungs. As she leaves the campus, heading down Fourth Street, she is thinking to herself, "Wow, I am so lucky!"

She tells me over the phone, "Mom, all the lights are broken, and a cop is at all of them motioning for me to go on through. Cool." Then she begins to notice all the broken down cars on the side of the road. "Can't believe how many people have broken down cars today, Mom." And then there is the moment when, "Mom, everyone is looking at me so sad." It is about this time that my honor student notices what is wrong with this picture. Yep, she is third in line behind the hearse. Somehow, she has gotten herself in a funeral procession. Now here is where you really know she is my clone. "Mom, I had to just go with them. I didn't want all those people behind me to turn at the mall. But I did look sad for all the cars that had stopped on the side of the road. I don't think they knew I was just going to get shampoo."

On behalf of my entire family, I would like to say, "She was raised better than that. We do apologize."

Defeated in the Aisles of Walmart

Well, it happened in Walmart, no doubt. I knew it would sooner or later. But what I didn't know was how hard it would be. It was just me against them. Hubby was not much help. He was just standing there, looking at us, whistling the Western dueling music every time I started to make a move. He had his doubts. For the record, I am slightly hardheaded when I am fighting for something I believe in, and this, friend, was of upmost importance to me. I paid no attention to the folks pushing buggies past me. And after about twenty minutes with my hands gripped tightly on that buggy handle, I knew one of us was going to have to make the first move. So I did. Yep, I ended up defeated, right there in the aisles of Walmart. I had a few tears, but I did it. Now I am not proud of my actions either, but when faced with a difficult decision, you just have to put your big girl panties on and do it.

I took a few deep breaths, looked up at the heavens, and rolled my eyes. Then I reached down and grabbed one—yep, reading glasses. Three pairs, in fact, because if I have to wear these things, they might as well match my outfits.

As the years went by, I found that not only does your eyesight change but also your memory does as well. It turned out three pairs were not nearly enough after all. In fact, between the hubby and I, we probably got about seventy-five pairs somewhere in this house, the car, and the yard. Only thing is, we cannot find them. After a while, you end up just buying the economy pack of glasses, going to lose them anyway. Old age is just a funny thing.

Back to the Working World

Sometimes, life will throw you a curve, and the only thing you can do is put your big girl panties on and deal with it. Take, for instance, when I had to return to the working world. Now I am not going to dwell on the reasons why, but let's just say we did not see them coming and leave it at that. Eli was already in college, and Rebekah was somewhere in high school. I can't remember what grade. Some of you may not know, but I left the working world years ago to help my husband with the family business. I called myself his secretary, but in all honesty, I did whatever needed doing. Whether it was helping hang the ductwork, entering payroll, picking up parts from the local part stores, or sweeping the floors at the jobsites, I did it.

Because I was the boss's wife, I did in fact get to make my own hours, though—the only perk of the job. Let's just say the pay was awful, practically nonexistent. When you are part of a family business, there is none of "That ain't my job," because truthfully, no one goes home until that day's work is done.

One time, I was picking up trash at a construction site when I looked up to find a former high school classmate peering inside the glass front window. He had a look on his face as if saying, "Well, she didn't go far." It was all I could do not to run after him and explain I did in fact go to college, but I didn't. I still had too much work to do, and this floor wasn't going to clean itself.

The day I made my mind up to go back to the real working world, I sent out a massive text message to all my friends and family: "Need job, right now." I knew I didn't need to return to nursing, because quite frankly, the twelve-hour days and rotating shifts would

not go well with what I still needed to do at the family business. And besides, it was only going to be temporary, right?

I'll be the first to admit, I cried to and from work the first couple of months. To say my world turned upside down was an understatement. For starters, I could not believe I was crawling out of bed before sunrise. My days of ponytails and sweatpants had ended abruptly. Oh, how I longed to just sit on my porch and read a book during the middle of the day. Thanks to a friend's husband, I soon found myself sitting behind the front desk of a local industrial company. I scrapped up enough brain cells to figure out their complicated multiline phone and paging system. Yep, it was not pretty at first, but soon, I found myself sounding like a real switchboard operator. Weeks turned into months, and months turned into years.

I will say my husband stepped up to the plate and begin helping with the household chores, and he eventually became a good cook, not overnight but eventually. It didn't take us long to realize I had spoiled him a little by taking care of all things woman at our house. Since he was at home more than I was, he would have supper ready when I got home. It was a good thing, because for the first six months of being in the working world, I went to sleep before 6:00 p.m. I kid you not. Sandwiches turned into microwave meals, which soon turned into his actually turning on the stove. The first time he made sweet tea only took four phone calls, but he did it. I will never forget the day he made his way out to our freezer. We had vegetables that night. I believe the meal was hamburger steak, green beans, butter beans, and peas. And we had lots of them—an entire week's worth of leftovers. Insert the lesson on the food pyramid.

Now granted, he had made many trips to the grocery store before, he just never went in for more than a few items at a time, but now he was shopping for the week and shopping on a budget at that. I will never forget the day he called and said an elderly lady stole his buggy. Now you all know, growing up in the South, there are some things you just do not do, and one of them is argue with a woman holding a cane. After he failed to convince her that in fact that was not her buggy, he made his way back to the front of the store

and started over. I still laugh out loud about this, and to this day, he doesn't get too far away from his buggy anymore.

Before things got a little better, they got a lot worse. I will never forget the day I arrived home and opened my back door to a thick cloud of dust. If the porch hadn't needed sweeping off so badly, I would have dropped down to my knees right then and there. "Oh, Dear Lord Jesus, what has he done now? If you will just give me a little bit of time before Crockett and Tubbs show up, I will have all this evidence gone, and his body tucked away real good."

I stomped into the kitchen telling my husband he best be moving this side job elsewhere because I did not plan on going to jail any time soon. Turned out he had not changed my kitchen into a cocaine factory after all, but this was just his attempt at making homemade biscuits. A five-pound bag of flour later, he had them—four of them to be exact. Of course, we had to eat them out on the porch because I did not want some sort of lung disease. Surprisingly, they were good. From that point on, I knew my kitchen would never be the same again. When he figured out the difference between powdered sugar and all-purpose flour, he even mastered the art of potato soup.

Last week, my husband reluctantly agreed to stop by the makeup store to get me some lipstick. I was completely out, and we all know in the South, that is against the law. I texted him the color of lipstick I wear so he would not forget. As he walked inside, the lady behind the counter asked," What are you looking for?" He looked down at his phone and said, "Hot Date." Once he cleared up the fact he was not asking her out, she helped him find me some lipstick. Insert rolling eyes. I am not sure whose idea it was, but I no longer wear that shade. And I am sure when he got back to his truck, he checked to see if his "man card" was still there. It was.

We may be walking through valleys, but we are walking hand in hand. I could not have done this journey without him. And if we will allow ourselves to be quiet enough, we can hear God walking right along with us. Blessed beyond belief.

So You See, Your Honor

Well, this morning, at 6:50 a.m., it happened. When you are married to the poster child for ADD, sooner or later, you find yourself thinking about where to hide his body. I was sitting in my car, looking at the front windshield that was frozen solid with ice, not just the windshield but also that squirt thing that sprays water. I had heard my husband say time and time again, "I'll get the garage cleaned out tomorrow so you can park your car in there." Do I need to mention it's twenty degrees outside and I can't be late for work?

I drove the car right up to the front steps and blew the horn so my husband could bring out a bucket of water. And he did. First, he poured some on the driver's side and next, a little on the passenger's side. The wiper blades were going as fast as they could, and soon, my window was good to go. This is where the story ends for normal people, but no, not us. The poster child walked back around to the front of the car to give me a kiss goodbye, or so I thought. I tapped my electric window button, and down went my window at the exact moment he released the final few gallons of water on my face—yep, on my face, my clothes, my hair, my makeup. Do I need to mention again it is twenty degrees outside? I climbed out of my car and stepped over my husband as he was rolling on the ground, laughing hysterically. He was laughing because he hadn't realized he had to sleep sometime and he should really be worried. Meanwhile, I headed back inside to change my entire outfit and blow-dry my hair. ADD at its finest, folks. If only my friend, Kim, would have just answered her cell phone that morning, we would be explaining to some judge right about now: "So you see, Your Honor, that is why we hid his body."

Fishing like a Girl

I'll be the first to admit it. I am not one of those women you will ever see climbing a telephone pole or riding the space shuttle to the moon just to prove a woman can do it too. Not that I have any doubts whatsoever that women can do it; I just did not get any of those "I must prove it" genes. You will probably never see me playing football in the mud or calling up a turkey or, heaven forbid, even skinning a deer. Wait, give me a minute to get that image out of my head. I am just not that kind of woman. I am more of the making casseroles, reading a book, and hanging clothes out on the clothesline kind of gal. Now I say all that to say this: I do fish. Granted, I am not that great and it usually causes my husband to drink when it is all over. But if you're married to a fisherman and if you want to spend any alone time with him, you got to get in that boat.

Girls, if you can make it back home without throwing him overboard, then you can call the day successful. Let me share a few things to help ease you into the world of fishing. No matter how big the waves get, you can make it safely back to shore. Cussing is optional; however, it will not calm the waters whatsoever.

Lightning storms are scary—very. Always ask your ADD husband several times before you leave the pier, "Are you sure you got enough gas?" If you are caught in the rain, don't spend a lot of time worrying about your hair. Focus more on the fact he is fixing to pull that plug out of the bottom of the boat. And when he does, cussing is optional.

Next, although you will only need one pole, for some unknown reason, he will need six of them. Finally, fishing lures do tend to get stuck in places you never dreamed. They will hurt when they do.

Cussing is optional. Oh, and no matter how tough your man is, an emergency room will be necessary if the lure is stuck anywhere on his neck. Just saying.

After experiencing my first trip out in a storm, I always check the sky. If there is a cloud anywhere in this state, I am staying home. Case in point, the day we went camping with a couple of friends. Insert lightning storm and tiny boats sitting under a tiny metal shed. God knew what He was doing when I decided to pass on fishing that afternoon. Now this is where I need to add something important. You know that saying "Women and children first?" Well, it was written for people like me. You might as well let me go with the kids 'cause I am useless when things get scary.

"Come get us. Hurry!" said my husband, wanting me to drive down to the lake and rescue them from the storm.

"Oh, I don't think so. It is lightning." I quickly pointed out. To which he added, "Yeah, I know, we are sitting in a boat in the water under a metal shed."

"I don't think that is wise. You should get out of there. That is dangerous," I replied. Insert silence from husband.

Now don't get me wrong. I felt bad, but then again, it was lightning. And not just a tiny little bit either, but I am talking about God unleashing what I like to call "cleansing of the soul" kind of lightning, where you get yourself right with the Man upstairs before it is over.

About this time, we began to have hail beating down on our little camper and also the tiny metal shed they have rowed their little boats into for cover.

"I'm scared, come back to the camper," I pleaded because this storm has now become serious.

This is when he lets me know that I was the one with the car. Well, he should have taken the car with him 'cause I am not leaving this camper.

Strange how heavy winds shaking the camper off the ground will change your mind—that and the fact that one of those folks in the tiny boat had a daddy that was a big-time judge. And I was not sure if the "every man for themselves" theory would actually hold up in court.

I stood at the camper door, holding tight to my purse, making peace with the Lord because I knew I was not about to take a Wizard of Oz trip in this tin box. Insert another call from Gilligan explaining that I had to get in the car and come get them. I dabbed a little lipstick on, slung my purse over my shoulder, jumped out of the tin box, and started singing hymns all the way to the car. If I was fixing to meet Jesus, I might as well be practicing the songs when I walk through heaven's gates.

The Bird Whisperer

Have you ever got the feeling the universe is trying to tell you something, only you do not understand the language? I really cannot explain it, but for some unknown reason, birds seem to flock to me while I am driving my car. Here a bird and there a bird, and soon, I begin to wonder if everyone else is having the same invasion of the birds trouble I am having. Apparently, if you start bringing up the fact that birds are dropping out of the sky around you, folks start making the sign of the cross, lighting candles, and grabbing Bibles.

My wake-up call that I should really be worried finally came years ago when the daughter and I were en route home from a long day in town. Out of nowhere, a bird slams into my windshield. Now I am not talking about a cute little bird, but none other than a massive king of all buzzards. After the initial shock of the loud thump, which immediately caused my daughter to return to the fetal position in the backseat, we were overcome by a horrific smell. I cannot tell you what the insides of one of those things smell like. You would not believe it unless you were there. I will share that if one is splattered all over your windshield, do not, repeat, do not turn on the wipers. No, no, no! It will not be pretty.

I had a screaming child in the back seat: "Mom, make it go away!" But I could not. In fact, I wanted to crawl in the back seat too. It was one of those moments when I just wanted to pull over, abandon the car, and just get another one. And remember—this is back when it cost four dollars a minute to make a call on those newfangled cell phones. I'll have you know, my husband had to listen to me cry all the way home.

Twenty minutes later, I wheeled into my driveway on two wheels and into the waiting water hose. I would like to say that this was my one and only encounter with a buzzard, but I'd be lying. It happened again, but that next time, I refrained from turning on the wiper blades. Lesson learned the hard way.

Now you may want to sit down. I am going to confess another sin. I hesitate to actually tell this mainly because I do not want to end up in jail. I would like to add for the record that if I end up on some kind of government wildlife endangered species watch list, I will say I made the whole thing up and I was probably drunk at the time.

The husband and I were heading home after a visit to the local steak house. We had just merged onto the interstate, setting the cruise control to seventy. Keep in mind, it was very dark, and although it was late in the evening, the interstate still had travelers on it.

Just as we approached the overpass, we came face-to-face with a creature from the dark. Never seen anything like it. This thing stretched all the way across my windshield. I don't know who was more scared, me or it. And I am not sure just how long Jesus had to take the wheel because I covered my eyes with one hand and, with the other hand, I latched on to my husband's arm. If we were fixing to end up dead, I didn't want him to be wandering around on the "other side" causing us to be late going through the pearly gates.

You know how everyone says that your life flashes before your eyes? Well, I don't know about that. I was too busy trying to find the light leading to heaven. "Where's the light, Chris? Where's the light?" Not that hitting an owl isn't enough to send you into a panic attack, try realizing you can't find the light when you think it should be there.

Except for my husband yelling, "Hands on the wheel! Hands on the wheel!" I don't think we spoke for the next twenty minutes. Insert me driving the rest of the way home at thirty miles an hour. And that two-beer buzz my husband had when we left the steak house was long gone.

Deputy for a Day

Let me tell you about the time I was a deputy with our local law enforcement agency. Yep, all about forty-five minutes, but it was the best forty-five minutes of my life. Well, except for the time I found Jesus, got married, and had kids and all important stuff like that. My friend, Beth, and I walked in the mornings for about an hour. Actually, to long-legged Beth, it was walking, but to me, it was a tad bit like running. But anyway, we had the same routine every morning. I showed up at her house, and her little dog, Seymour, tried to attack me at the door. I threw my keys on her counter, and off we went. We pretty much followed the same route every day, except for on the days the garbage truck comes through our neighborhood. Yep, in the summertime in the South, it is best not to follow behind the garbage truck. It didn't take us but once to learn that lesson.

Anyway, here is how it went down. I returned home all sweaty because, well, I am out of shape and old. I noticed a vehicle in my driveway. *Hmm, who can this be?* I wondered. Now if you remember my saying, "God takes care of stupid people," and once again, He was watching over me.

Something told me not to pull into my garage, but instead, I tried to call my husband. Insert rolling eyes here. He didn't answer, and I didn't know why I even bothered with that. Now this is where all those *Criminal Minds* and *CSI* television series come in handy. I decided to put on my imaginary badge and go to work.

Why, you ask? Because I am stupid.

Anyway, I reached into my purse and pulled out my weapon of choice: a slightly used iPhone. Now I say weapon of choice, but truthfully, it is the only weapon my family will allow me to get. Insert

rolling eyes again. I commenced to gathering evidence and taking photos. It was at this time I really wished I had me one of those fancy fingerprint kits because, well, I just really want to do that.

Next, I carefully reached into the suspect's vehicle and pulled out his ID that he so casually left on the front seat. Yeah, he didn't see that coming, but then again, I didn't either. It was about this time I saw him exiting my backyard, and it was here that I realized I may not be the brightest crayon in the box because I don't have a plan B or a gun.

I jumped back into my vehicle and locked the door. After a brief conversation with the said criminal, I politely told him to hold still. I got to take one more picture, and I got a really good one of his tag. Apparently, this was when he decided to get nervous, and he jumped back into his car.

Now, folks, I really thought I had this criminal blocked in with my big old car, and in my mind, we were going to just sit there and wait until 911 arrived. Insert me misdialing 911 twice. Who knew that he would leave the driveway and travel through my grass? Well, dang. This is where the story should end for normal people, but no, I must follow him.

Why, you ask? Well, I don't really know, but this is how they do it on TV.

All I was missing was the blue flashing lights. You know, I believe I could have caught him too, but the 911 lady made me stop my hot pursuit and go back home. Well, dang.

So I was in my driveway, waiting for the officers to get to my house, and sure enough, they showed up pretty fast. Of course, while waiting, I called my partner in crime, Beth, and my sister, Terri—who lives in the same neighborhood—to explain why I nearly ran her off the road a few minutes earlier. They too have gathered along with the gentleman I frantically grabbed off the street to wait with me because I am scared.

After the officers made sure my house was secure, I proceeded to report my findings. Now picture this, if you will. We are huddled together in my driveway, all the while the onlookers were watching from a distance, just like in the movies. It was probably safer that way

because we had official business to conduct, you know. They were in constant contact with dispatch, and I was reviewing my notes and sharing my evidence. Why, if it wasn't for the fact they had muscles, lots of muscles, radios, and guns and I didn't, we could have all passed for twins. Folks, you can't find a big muscle on me even if you were to dissect all of mine and put them together with super glue. I would nod my head occasionally and look over to the crowd as if I had received some important secret facts in this case and we were planning our next move.

I will have to say those two officers did a great job, and it was no time that my criminal had been arrested and thrown in jail. To all you womenfolk out there, I would like to point out a few things. First off, when officers are searching your house, they will look in your closets. Insert rolling eyes. My closet looked like there had been some sort of explosion. In fact, I almost lied and reported that the criminal had destroyed my closet. "OMG! Look what the criminal did to my closet!" But I didn't.

Secondly, make your bed and wash your dishes before you leave your house—always. And finally, when you go walking in the mornings with your best friend, make sure you brush your hair and put on your lipstick. You just never know what is going to happen around the next corner. Oh, and no matter how many times you ask your husband to call 911 again to see if the deputies could come back and take a look at your now cleaned closet, he won't. I'm seriously thinking about sending them a picture anyway so they can add it to my case file.

And there you have it, folks, my day as a deputy. I will add there is one more difference between me and my deputies. I bet neither one of them has to sleep with the lights on now.

Easter Sunday

Tonight after supper, I realized again that the Easter Bunny will not be stopping by my house.

How quickly I forget these things. My babies are grown adults now, and I really do miss it—the sweet pink ruffles on my baby girl, the handsome little suits on my boy, the baskets filled with candy, and the Sunday dinners fixed with all the trimmings. You know, hiding Easter eggs was a family tradition as I am sure it is yours too. Of course, my relatives gave a whole new meaning to the words *prize egg*. You see, before the big hunt, the men would reach into their wallets, pulling out money for the kid that found the special egg.

But here is where our tradition may differ from yours. The menfolk hid the eggs. The reason being was because they would hide one of those special eggs for the women to find too. I couldn't wait to get old enough to join in with the hunt for the grown-up prize egg. The money was good, and honestly, it would have to be because they hid that egg in some awful places. Let's just say that if you didn't need to wear gloves to find it, they weren't hiding it well enough.

Yes, sir, some years, it took over an hour to find that stupid egg, but not one of us women would give up. The men would just laugh and laugh because we were digging up the yard, or taking apart swing sets, or looking under cow paddies. Hey, I'm not proud of my actions, but it was the prize egg, you know, and they made that prize worth digging around for it. I actually think they would start planning months in advance.

One year, that stupid egg was under a baseball cap sitting on top of my uncle's head. I can still hear it now: "Aunt Gay is getting warmer." or, "Aunt Yevonne is too cold." or, "One of you is just about

touching it." Dang it! A test of being a true Southern lady at our house was digging in a bag of fertilizer, all the while keeping your new Sunday dress clean.

Now before you all start yelling that we have missed the whole reason for the holiday, we didn't. Although, there were times it looked like we may have been part of the twice-a-year church service club. For instance, the year we decided to go to the sunrise service at Mother's church.

"It is going to be beautiful," Mother said. "It is outside this year."

Keep in mind: this was the church I attended before I got married and moved away, so I still knew everyone there. It took hours of chaos to get my babies ready for this crack of dawn service and over to Mother's house to pick up the rest of the family. I should have just let them sleep in their church clothes, wrinkles, and all. I am not even sure if everyone got fed.

"Here, just eat the ear off this chocolate bunny." I found myself telling the kids, not sure I brushed my hair that morning either.

We wheeled into the parking lot, running through that fellowship hall, and out the other side door to see that the service had already started. We quietly eased up to the back row and stood. Imagine my surprise when everyone said, "Amen!" This was followed by the preacher instructing everyone to please stay for coffee and donuts in the fellowship hall. Incidentally, that was the last year Mother was in charge of finding out what time sunrise service started.

Church Memories

I am a routine person, and as always, before Sunday service starts, we sit in the lobby while my husband drinks a cup of coffee. Officer Larry, our friend, always stops by our table for a visit. The preaching staff is busy talking to everyone as they exit one service and before they enter for the next. We see members of our old Sunday school class and parents of our children's friends. We hear news of upcoming graduations, jobs, weddings, and news of grandchildren soon-to-be born. I continue to be amazed at how fast the little children are growing up into teenagers and the teenagers that used to frequent our house are now parents themselves. Time passes so quickly.

Today, as I was people watching, I was taken back to the days when my children were little and running around the church grounds. I remember packing diaper bags and bottles for them when they were in the nursery. I remember the colored papers they would bring home with the stories of Jesus that they had learned that day. I remember volunteering for our share of Sunday school classes, vacation Bible schools, and nursery duties.

I remember when Rebekah got old enough to bake cookies to add to the meals being brought to members who may have needed a meal or two. I remember the day she put a handwritten note addressed to God in the offering plate and wanted Brother Jerry to hand deliver it.

I remember the mountains of Fruit Loops or Cheerios that were needed to keep them still in "big church," and no matter how many times you would ask them before church, someone always had to go potty once the preaching started.

I remember the day Eli tossed a Cheerio into the beehive hairdo of the lady sitting in front of us. I remember vividly the day he raised up two shoes high in the air during the middle of the sermon. And how embarrassing it was to have to return them to the man they belonged to sitting behind us. I think this was when I introduced being a back row Baptist to my little family.

I remember the day we finally thought Eli was old enough to go to the bathroom by himself and how scary each of the minutes was when he didn't return. My husband had to get up during the sermon and work on the bathroom stall door to get my child out of there.

I remember the sermon Brother Paul preached when Eli jumped up onto the pew, raising his hand. He knew the answer to the preacher's question and was determined that he was going to be the one to answer. I remember the day the church prayed for my son before he went to Africa. It was such a comfort to a mother's heart knowing that everyone was talking to God at that moment about my son and that God was listening to their prayers.

I remember the man who had the flu sitting behind us one morning. I know my husband did not hear one word of that sermon 'cause he spent the entire service dodging the germs the man was coughing toward the back of his head. By the time the sermon was over, my husband had slid all the way down in the pew. "Mommy, what is Daddy doing?"

I remember the day my ADD husband got his watch stuck in my hair clip as he placed his arm around my shoulders. I remember the giggles from the older adults who enjoyed watching that fiasco unfold and how embarrassing it was to have to ask them to help us get untangled.

Baby dedications, children's programs, and baptisms—they are all such wonderful memories. Although it seems like just yesterday, I realize it wasn't. My prayers when they were little were that they would find salvation with Jesus as their Savior, and before they were to be grown and gone, that we would just once make it to church on time.

Printed in the USA
CPSIA information can be obtained
at www.ICGtesting.com
LVHW042009060823
754442LV00008B/535